IMAGES
of America

AROUND
CRAWFORD

IMAGES
of America

AROUND
CRAWFORD

Fritz G. Meier

ARCADIA
PUBLISHING

Published by Arcadia Publishing
Charleston SC, Chicago IL, Portsmouth NH, San Francisco CA

Printed in the United States of America

Library of Congress Control Number: 2009933575

For all general information contact Arcadia Publishing at:
Telephone 843-853-2070
Fax 843-853-0044
E-mail sales@arcadiapublishing.com
For customer service and orders:
Toll-Free 1-888-313-2665

Visit us on the Internet at www.arcadiapublishing.com

To the future generations of the Town of Crawford

CONTENTS

ACKNOWLEDGMENTS

I would like to thank everyone that contributed photographs and stories for this book; I hope that I conveyed your stories as accurately as possible. I would like to express gratitude to over 40 different people that contributed photographs for this book. The individual photograph credits identify all of them. I would also like to thank the Pine Bush Area Library for allowing me access to their collection of reference materials. I would like to thank Burk Uzzle for granting me permission to use his famous 1969 photograph of Bobbi and Nick Ercoline in this book. I would like to thank Alayne Eisloeffel for typing most of this manuscript and Joe Rimstidt for his help with some of the images. I would like to thank R.J. Smith and Joanne K. Keillor for their support and help with proofreading the manuscript. I would like to thank my editor Rebekah Collinsworth and Arcadia Publishing for giving me the opportunity to publish *Around Crawford*. I would like to thank Libbie Werlau, author of *Plattekill*, for her encouragement, guidance, and advice. My apologies to anyone I forgot to mention. My omission is not intentional and I thank you. I would like to thank my children, Tess and Cole, for being so supportive and understanding while we worked on this project. I could never have done this without your help. Last but not least, I would like to thank my wife, Gretchen, for her being there with me and for me while I tackled this book. I love you.

INTRODUCTION

The land area that is the town of Crawford was once part of Ulster County, one of the original counties created by the English government in 1683. In 1694, Capt. John Evans, commander of the HMS *Richmond* was granted a land patent from the King of England. The Evans Patent was a large tract of land that included what is now the town of Crawford. The Evans Patent was divided over the years and smaller patents were created. In 1709, Jacobus Bruyn received a patent for the tract of land, which included parts of the present-day town of Crawford. In an effort to centralize government, the southwest corner of Ulster County became part of Orange County. This section of land was originally the town of Montgomery, which would later divide again to become the town of Crawford and the town of Montgomery. This division is further explained below.

In 1823, Moses Crawford petitioned New York State to divide from the town of Montgomery, since the land covered by the town of Montgomery was too vast to conduct business in an efficient manner. On March 4, 1823, the State of New York granted this request, and the Town of Crawford was established. The town is named after the Crawford family, early settlers of Irish descent who were well respected in the area. The first town meeting was held at the home of Edward Schoonmaker on April 1, 1823. The first town supervisor chosen was William Crawford. The first town meeting selected a full list of town officials, including the offices of town clerk, assessor, collector, overseer of the poor, commissioner of highways, constable, school commissioner, school inspector, and fence viewer. It was also decided that they would place a $25 bounty on any wolf killed within the town. Searsville was the geographic and population center of the town, thus it was considered to be where town meetings would be held. In later years, town hall was established in Pine Bush, where it remains today.

There are several communities within the town of Crawford, including Searsville, Thompson Ridge, Pine Bush, Hopewell, Collabar, and Bullvillle. There are several rivers and streams that run through the town and they contributed to the settlement of the area. The Shawangunk Kill ("kill" is the Dutch word for river or stream), the Dwaarkill, and the Little and Big Paughcaughnaughsink Creeks all travel through the town. It was on these rivers that lumber mills and gristmills were established.

One of the first areas of settlement was along the Dwaarkill in Searsville. In 1768, Johannes Snyder built a lumber mill on the Dwaarkill and the area was first known as Snyder's Mill. He also built one of the first churches in the area that was constructed out of logs. The church services were presented in Dutch. This church was no longer in use by the Revolutionary War. Benjamin Sears built another sawmill and a gristmill on the Dwaarkill, and this area was known as Searsburgh, which later evolved into present-day Searsville.

There is a small community between Thompson Ridge and Burlingham that is known as Hopewell. The people that settled here were from the Goodwill Presbyterian Church congregation in Montgomery. It is in this area where the Hopewell Presbyterian Church had its start. When the congregation of Hopewell grew, it moved to Thompson Ridge. The site of the original church is

not known. The Hopewell Cemetery is located on Orange County Road 48, and it has the graves of many of the town of Crawford's early settlers. Although Hopewell did not have substantial commerce, it was a busy farming community.

Bullville is named after Thomas Bull, the son of William Bull who was an early settler in Hamptonburgh. Thomas Bull's son Daniel Bull started farming his father's land in Bullville and upon his father's death was bequeathed the land. Daniel Bull married Catharine Miller in 1780, and the two built their stone house on what is now Roberson Avenue in Bullville. Daniel and Catherine Bull had 13 children who helped farm their land. In 1810, the Newburgh to Cochecton Turnpike was built. The turnpike was a toll road that was privately owned and maintained, and teamsters had to pay a toll to travel on it. Daniel Bull was the director of the turnpike for around 40 years. The Newburgh to Cochecton Turnpike helped establish Bullville and the community of Collabar as the center of commerce within Crawford. The turnpike was utilized until 1871 when the Middletown and Crawford Railroad began operating. Today the Newburgh to Cochecton Turnpike is known as New York State Route 17K.

Collabar is also located along the Newburgh to Cochecton Turnpike. It was the home of Moses and Archibald Crawford. Moses helped organize the town of Crawford, and Archibald was a surveyor who drew one of the first maps of the town in 1844. This map hangs in the Crawford town hall. Collabar, once known as Collaburgh, had a school, blacksmith shop, hotel, and various other buildings with stores and shops. The cemetery on the hill near the end of Collabar Road contains the graves of Moses and Archibald Crawford and their families. Collabar prospered until 1871 when the Middletown and Crawford Railroad began operation and travel on the turnpike decreased.

In the 1770s, the three Thompson brothers bought a 500-acre parcel of land in what is now referred to as Thompson Ridge. The brothers Alexander, Robert, and Andrew each built homes along the ridge and farmed the rich fertile soil. The three houses are still standing, and they have all been placed on the National Register of Historic Places. A descendent of the Thompson brothers, Daniel Thompson, is credited with organizing the Middletown and Crawford Railroad. The rail bed went right through the heart of Thompson Ridge and brought commerce and trade to the hamlet. The endless farms that once dotted the countryside brought their milk to the creameries that were served by the railroad.

Pine Bush has been called several different names over the years. It has been known as Crawford, Shawangunk, Bloomfield, and finally Pine Bush. The name Pine Bush is thought to have been derived from a large stand of pine trees in the hamlet. Pine Bush started to thrive around 1848 with the building of the plank road from Ellenville to Newburgh, which is now called New York State Route 52. Pine Bush later grew again with the addition of the Middletown and Crawford Railroad in 1871. Pine Bush was the terminus point of the railroad and prospered with the influx of passengers. There was once a turntable—now under a parking lot on the corner of Railroad Avenue and Depot Street—used to turn the train around for its return trip to Middletown. Pine Bush is the largest hamlet within the town of Crawford.

There are some images in this book that were taken outside Crawford, but they were included since they seemed to fit with the topics depicted in this book.

One

SEARSVILLE

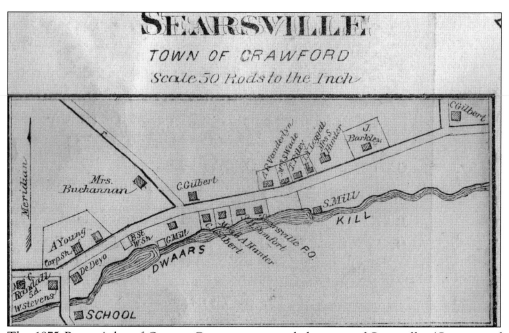

The 1875 Beers Atlas of Orange County contained this map of Searsville. (Courtesy of Fritz Meier.)

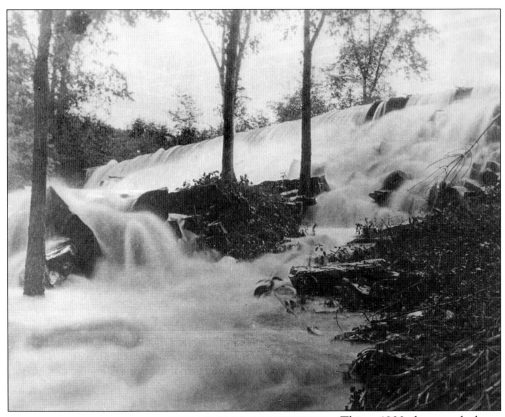

This c. 1900 photograph shows the waterfall created by a dam in the Dwaarkill in Searsville. The Dwaarkill powered several mills, including a gristmill and a lumber mill. Searsville was originally called Snyder's Mill after Dutch settler Johannes Snyder built a lumber mill near this point in 1768. (Courtesy of Elsie Rumpf Johnson.)

The Judson house shown in this 1890s photograph was landlocked. It was accessed by driving through the Samuel Richardson farm on Orange County Road 17. Eventually Judson Road was built to access this house. This building burned down in the 1970s. (Courtesy of Helen Anderson Richardson.)

This is the Abraham Dickerson house located at the corner of Orange County Road 17 and Hill Avenue. Built in the late 1700s, it served as a lumber mill until the early 1800s. The Todd McKinnie family is seen in this *c.* 1900 photograph in front of their home. The building still stands. (Courtesy of Helen Anderson Richardson.)

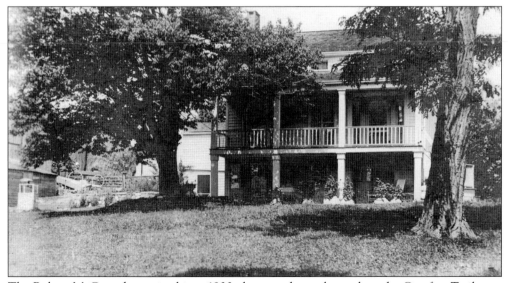

The Robert McCann house in this *c.* 1900 photograph was located on the Comfort Trail near the stone Comfort family house. (Courtesy of Helen Anderson Richardson.)

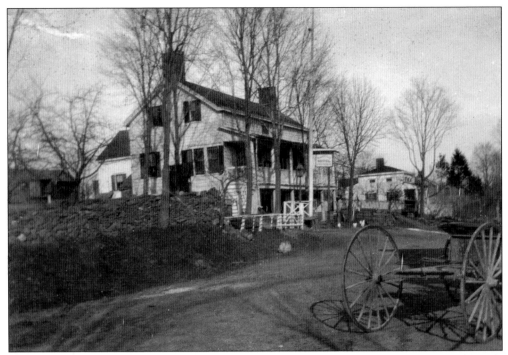

This *c.* 1912 photograph shows the hotel in Searsville. The building was located on the left side of the road as one travels from the intersection of Orange County Road 17 and Collabar Road toward New York State Route 52. (Courtesy of Elsie Rumpf Johnson.)

Organized in 1904, the Searsville Grange bought Morrison's store on the banks of the Dwaarkill for their new hall. In 1909, it was decided to tear down the old store and erect the new Grange Hall. The building is now a private residence. (Photograph by Fritz G. Meier.)

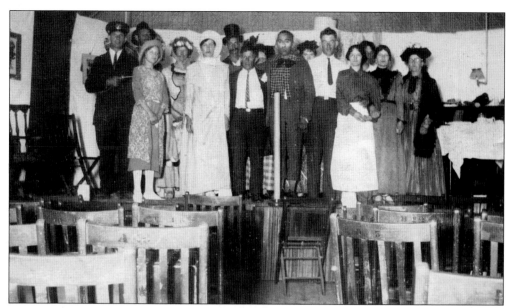

In 1909, the Searsville Grange met in the newly constructed Grange Hall. This early 1920s photograph depicts a cast from one of the theatrical performances that took place in the Grange Hall. (Courtesy of Helen Anderson Richardson.)

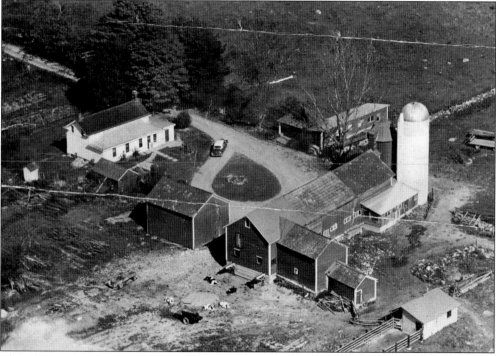

This 1953 aerial photograph shows Fred and Helen Richardson's farm. It was originally owned by Samuel Richardson until his passing in 1940. The farm was taken by Orange County in 1970 from the Richardsons under eminent domain for the planned Dwaarkill Reservoir. The reservoir was never constructed, and the buildings in this photograph were demolished. (Courtesy of Helen Anderson Richardson.)

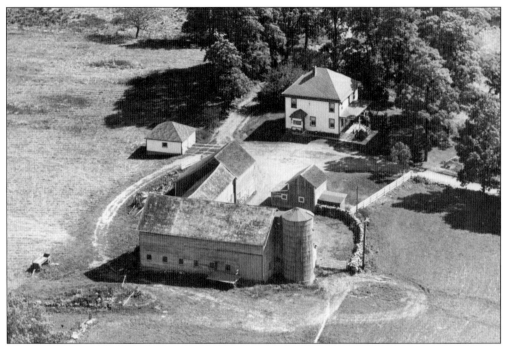

The home belonging to Peter and Laura Richardson, where they farmed around the turn of the 20th century, was located on Comfort Trail near Orange County Road 17. This aerial photograph was taken in 1953. The farm was spared from the Dwaarkill Reservoir project and still stands today. (Courtesy of Helen Anderson Richardson.)

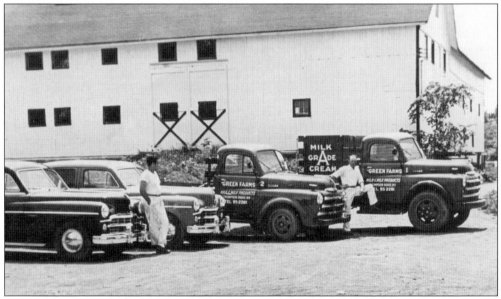

In 1943, Joseph Green purchased the Addison Crawford and Donald Callan farms in Searsville to start Green Farms. His son-in-law Isadore "Stitch" Wittenberg started to bottle milk in 1948. He later produced ice cream with the help of his son Jeffery "Chief" Wittenberg. The barn in this 1950s photograph burned in 1958. Green Farms was sold in 1990, and ice cream production stopped. (Courtesy of the Wittenberg family.)

Two

THOMPSON RIDGE

The Alexander Thompson house was the first of the three family homes built on the 500 acres purchased in the 1770s by the Thompson brothers. The original section of the house was built between 1773 and 1776. The main part of the house, seen in this photograph, was added in 1822. The house was continuously owned by a Thompson until 1997. It is now owned by Daniel and Virginia Hughes. (Photograph by Fritz Meier.)

The Andrew Thompson house, located on New York State Route 302, was built in 1810 on part of the 500-acre tract purchased in the 1770s by the Thompson brothers. This house was lovingly restored by Kenneth and Diane Schliphack and made their own. (Photograph by Fritz Meier.)

The Robert A. Thompson House was built in 1822 on part of the original 500 acres that the three Thompson brothers purchased around 1770. The house, located on New York State Route 302, is now the home of Dr. Peter Carmel and Dr. Jacqueline Bello and is on the National Register of Historic Places. (Photograph by Fritz Meier.)

The congregation of the Hopewell Presbyterian Church started meeting in 1779 in the area that was known as Hopewell, located between Thompson Ridge and Burlingham on Orange County Road 48. Some of the founders of the church were from the town of Montgomery's Goodwill Church congregation. The exact location of the original church is unknown. The church was incorporated in 1800. (Courtesy of Elsie Rumpf Johnson.)

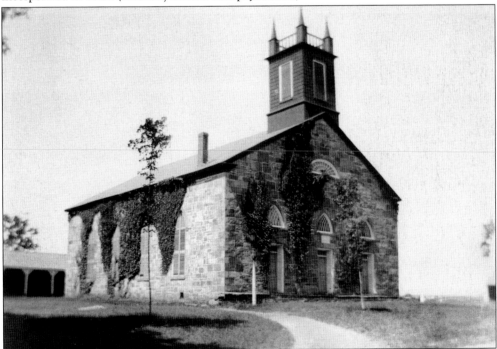

In 1831, the Congregation of the Hopewell Presbyterian Church started construction on the stone church in Thompson Ridge. The first church service was held in the new church in 1832 and is still active 167 years later. In 1968, the fellowship hall and Sunday school classrooms were added to the left of the church. This picture was taken around 1908. (Courtesy of Elsie Rumpf Johnson.)

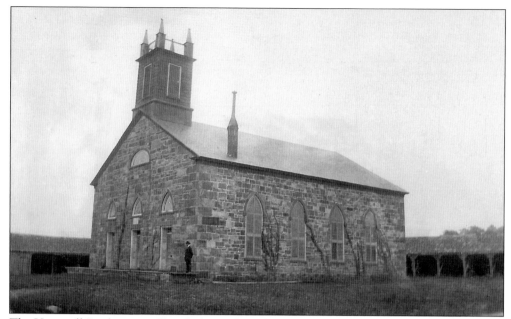

The Hopewell Presbyterian Church, located on the corner of New York Route 302 and Orange County Road 17 in Thompson Ridge, is shown in this 1898 photograph. The carriage shed behind the church was used by the parishioners to keep their horse-drawn buggies in during Sunday morning services; it was razed in the 1940s. (Courtesy of Louis Roberson.)

This 1950 photograph shows the interior of the Hopewell Presbyterian Church in Thompson Ridge. The children in this photograph are the Sunday school class for the year. The stained-glass windows (far left) were given to the church by the Webb Horton Presbyterian Church in Middletown when they replaced their windows. (Courtesy of Helen Anderson Richardson.)

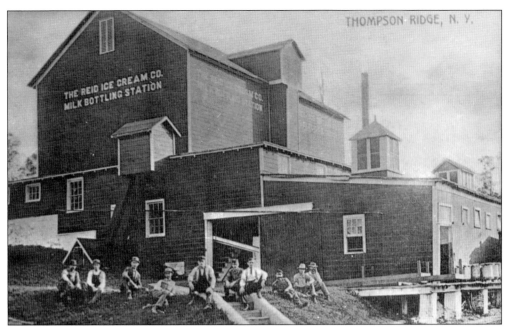

The Reid Ice Cream Company in Thompson Ridge was located on the east side of the Middletown and Crawford Railroad track on Orange County Road 17. It closed in 1905. (Courtesy of Elsie Rumpf Johnson.)

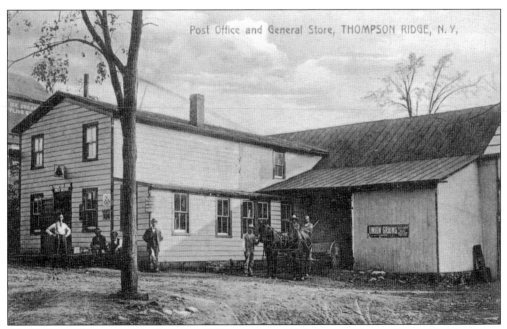

Clark's General Store and the U.S. Post Office in this c. 1900 photograph were located in Thompson Ridge. The Middletown and Crawford Railroad tracks were located between this building and the Reid Ice Cream Company seen in the background. (Courtesy of Elsie Rumpf Johnson.)

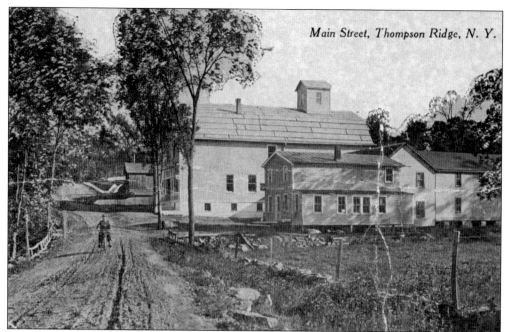

Main Street, Thompson Ridge, N. Y.

This *c.* 1918 photograph shows the U.S. Post Office in the foreground and the newly built Clark's General Store in the background. Orange County Road 17 is the dirt road viewed in this photograph heading toward Searsville. (Courtesy of Elsie Rumpf Johnson.)

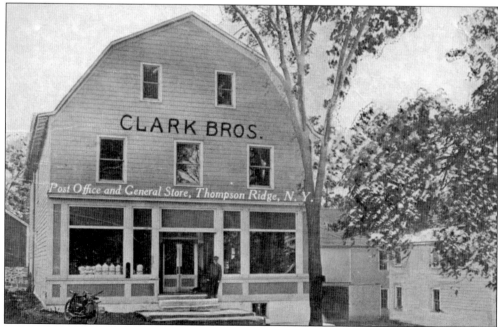

CLARK BROS.

Post Office and General Store, Thompson Ridge, N. Y.

The Clark Brothers store in Thompson Ridge was owned by Theodore and George M. Clark. This 1920s postcard shows the new store and the old one to the right. It also housed the U.S. Post Office for Thompson Ridge. Ira Clark, the grandfather of Theodore and George, helped to organize the town of Crawford in 1823. (Courtesy of Betty Rumpf Moorehead.)

This turn-of-the-20th-century photograph shows the blacksmith shop in Thompson Ridge. It was located near the present location of the U.S. Post Office in Thompson Ridge. (Courtesy of Elsie Rumpf Johnson.)

This 1890s photograph looks up toward Orange County Road 17 and New York State Route 302 in Thompson Ridge. The building on the right is the blacksmith shop. The Middletown and Crawford Railroad track is behind the photographer. (Courtesy of Elsie Rumpf Johnson.)

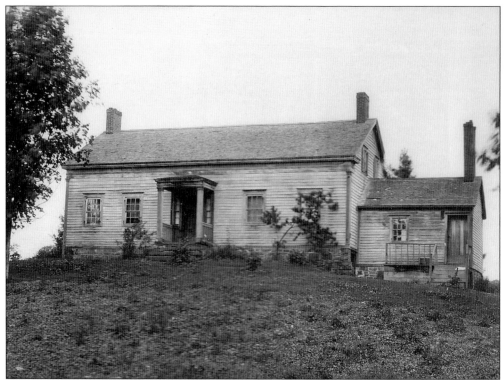

This 1898 photograph shows a house on Andrews Road that was originally owned by Sanford Shorter and then by Patrick Corcoran at the time it was taken. (Courtesy of Louis Roberson.)

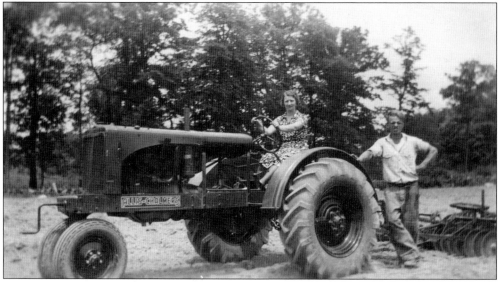

The Thorndale Dairy Farm was started by Jack and Myrtle Thorn, who are shown in this c. 1940 photograph. Their farmhouse on Orange County Route 17 was once the home of Daniel Thompson, who started the Middletown and Crawford Railroad. In the early 1960s, Jack and Myrtle opened the Thorndale Dairy Bar on the corner of New York State Route 302 and New York State Route 52 in Pine Bush. (Courtesy of Helen Anderson Richardson.)

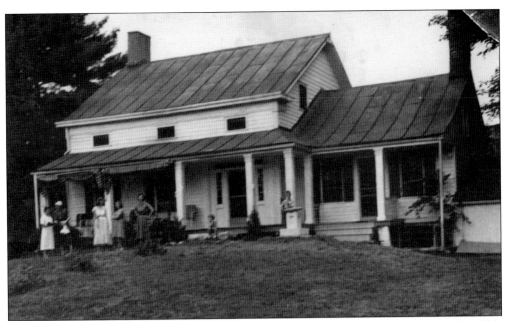

What was begun by Mr. and Mrs. James Morrow as the Little Bear Camp for boys in the 1920s became the Pine Bush Bible Camp in 1942. The camp is owned by the nonprofit Christian Bible Conference in northern New Jersey. Pictured here in 1942, this house, used by the camp, was built in 1844. (Courtesy of Lillian Clenk Spinelli.)

The 1926 brochure for the Little Bear Camp boasted "pure mountain water from protected wells" and a "modern water system" with "sanitary flushing closets," as seen in this 1942 photograph. The cost of attending the "Real camp for real boys" was $200 for July and August. (Courtesy of Lillian Clenk Spinelli.)

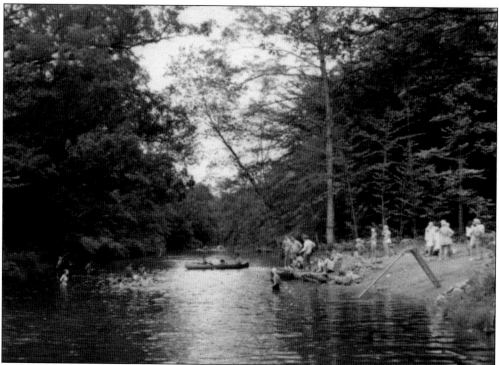

Campers from the Pine Bush Bible Camp swim in the Shawangunk Kill in this 1942 photograph. Howard Clenk, a board member of the Christian Bible Conference, helped to purchase the camp after seeing it advertised in the *New York Times*. (Courtesy of Lillian Clenk Spinelli.)

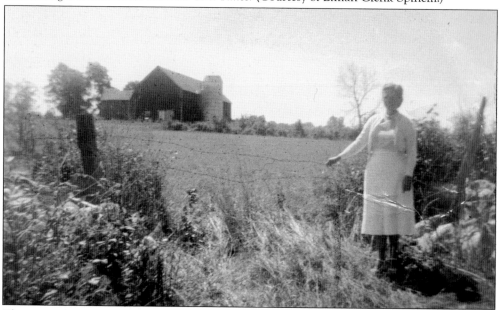

This 1949 photograph shows Dorothy Mason, the camp nurse from the Pine Bush Bible Camp, standing on what is now Bible Camp Road, near the present location of Dogwood Lane. The farm in the background was owned by C. Irving Dunthorne, namesake of Dunthorne Drive. (Courtesy of Lillian Clenk Spinelli.)

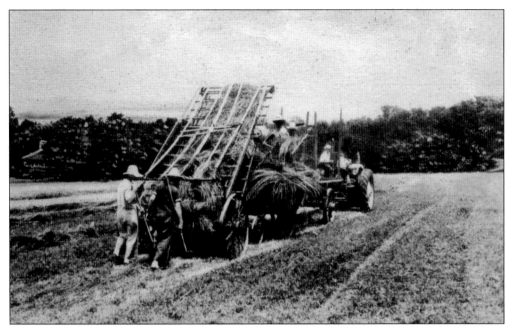

This 1940s postcard shows the Dunthorne family gathering hay on its farm on Dunthorne Drive. Driving the tractor is Barbara Dunthorne, on the fender is her cousin Jerry, and C. Irving Dunthorne is one of the men on the hay wagon. (Courtesy of Barbara Dunthorne Grey.)

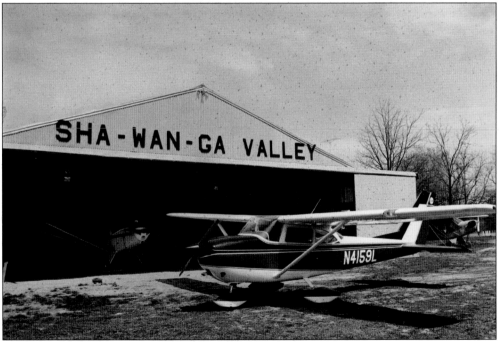

Sha-Wan-Ga Valley Airport was built by Leslie "Les" Horton and his wife, Tina Horton, over a four-year period starting in 1959. It was run continuously from 1963 until 1979, when it was sold. Lying dormant for three years, it returned to the Hortons in 1982 and was operated again by the Hortons until 1986. (Courtesy of Tina Horton.)

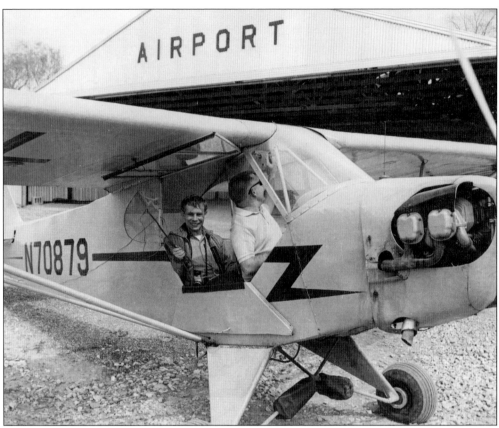

Located at the intersection of Stone Schoolhouse Road and Petticoat Lane, the Sha-Wan-Ga Valley Airport provided flight instruction, charter service, banner towing, skydiving, and aerial power line inspection services. This 1965 photograph shows owner Les Horton and Kenneth Hall preparing for a flight in a Piper Cub. (Courtesy of Tina Horton.)

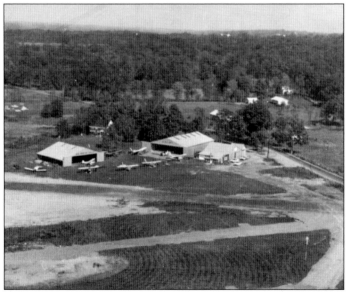

Sha-Wan-Ga Valley Airport had two hangers, which could house 18 aircraft with space outside for up to 20 aircraft tie-downs. The Hudson Valley Skydiving Club jumped here from 1968 until 1978. The Hortons sold the airport in 1986. It is currently used as an airport for ultralight aircraft. (Courtesy of Tina Horton.)

Three

BULLVILLE

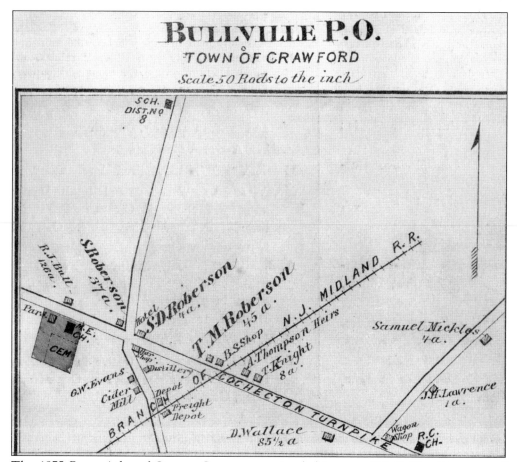

The 1875 Beers Atlas of Orange County contained this map of Bullville. (Courtesy of Fritz Meier.)

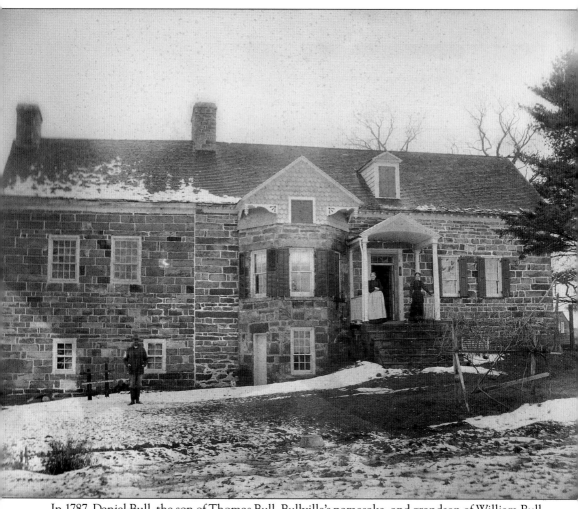

In 1787, Daniel Bull, the son of Thomas Bull, Bullville's namesake, and grandson of William Bull, one of the earliest settlers in the county, built the Peppercorn Farm on Roberson Avenue. It is said that Daniel bought the land from his father for one peppercorn, the smallest legal denomination allowed at that time. This 1898 photograph shows, from left to right, Capt. Theodore M. Roberson, Josephine Bull Roberson, and Amy Bull Roberson. (Courtesy of Louis Roberson.)

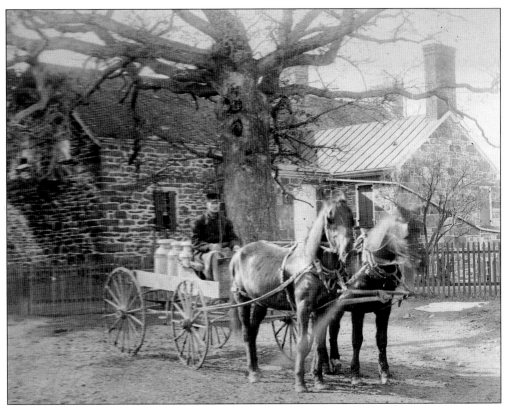

Capt. Theodore M. Roberson is seen in the 1898 photograph taking milk to the creamery in Bullville. Roberson enlisted in the 124th Orange Blossoms Regiment for the Union army in 1862. He was wounded during the Civil War and mustered out of the Union army with the rank of captain. The Daniel Bull house is seen in the background. (Courtesy of Louis Roberson.)

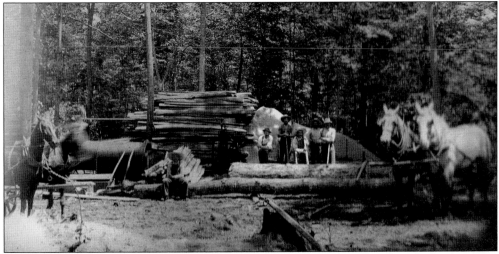

This photograph shows local men from Bullville harvesting and milling logs for lumber. This photograph was taken in 1898 near Bullville Lake. The large sawdust pile behind the men was used by local residents in their icehouses as insulation to prevent melting of the ice. (Courtesy Louis Roberson.)

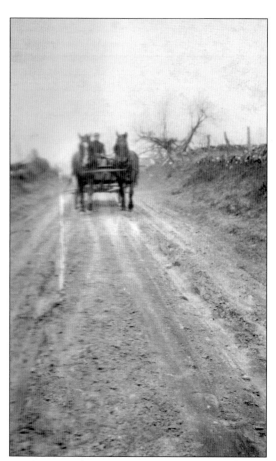

The Newburgh to Cochecton Turnpike was utilized heavily until 1870 when the Middletown Crawford Railroad began service. This 1918 photograph shows a team of horses on the turnpike, which is now known as New York State Route 17K. (Courtesy of Eric Palazolo.)

George B. McKney was one of two blacksmiths in Bullville in this 1898 photograph. His shop, which no longer stands, was located next to the Bullville Grange Hall on New York State Route 17K. The Grange Hall was located to the right of this building and still stands today. (Courtesy of Louis Roberson.)

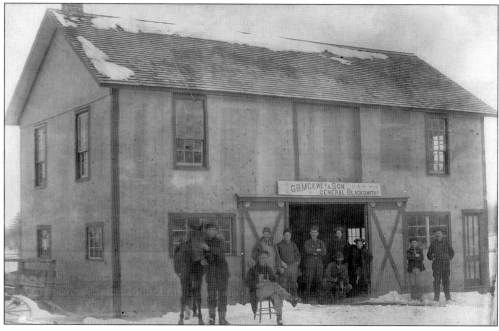

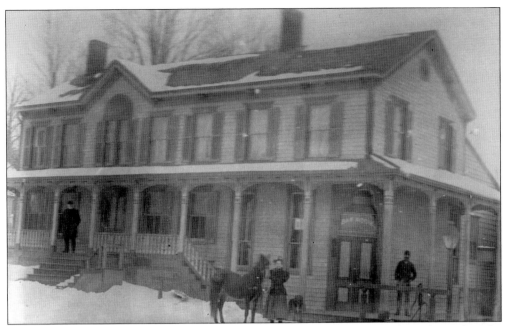

This *c.* 1898 photograph of the Dickerson Hotel, built by Silas and Lilly Decker, is located on the corner of New York State Route 17K and State Route 302 in Bullville. The intersection of these two roads, as well as Lybolt Road, makes up what is known as the "Five Corners" in Bullville. The lot is vacant in 2009. (Courtesy of Louis Roberson.)

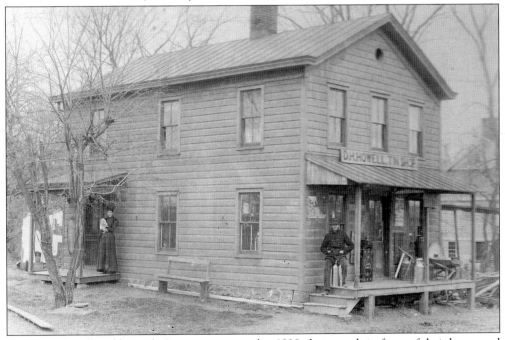

David H. Howell and his wife, Jane, are seen in this 1898 photograph in front of their home and the D. H. Howell Tin Shop in Bullville. The house is now a private dwelling and is located on Lybolt Road, opposite the U.S. Post Office. David Howell later moved his shop to New York State Route 302. (Courtesy of Louis Roberson.)

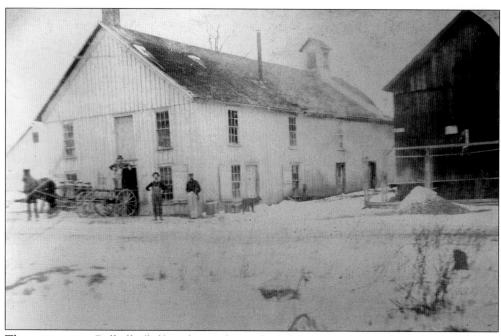

The creamery in Bullville (left) and its icehouse (right) are seen in this 1898 photograph. The Bullville Lake and other surrounding ponds supplied the ice for the creamery. (Courtesy of Louis Roberson.)

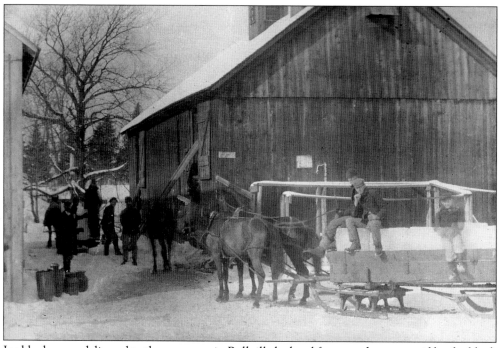

Ice blocks were delivered to the creamery in Bullville by local farmers who were paid by the block to transport the ice. (Courtesy of Louis Roberson.)

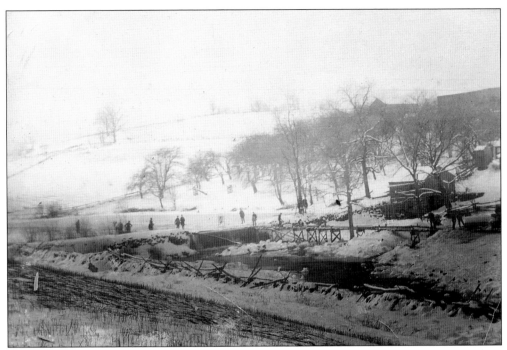

This 1898 photograph shows the local residents of Bullville harvesting ice from a pond on Burlingham Road. The farm is currently owned by the Detch family. A wooden chute was constructed from the dam to awaiting wagons so the ice did not have to be lifted and carried. (Courtesy of Louis Roberson.)

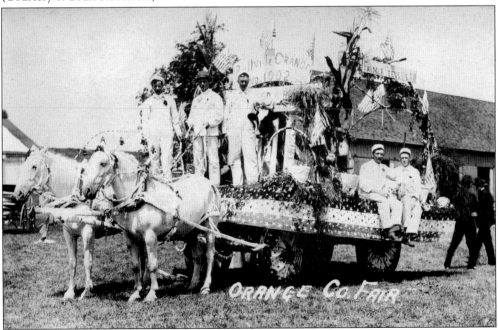

This is a photograph taken around 1900 of the Bullville Grange's horse-drawn float for the Orange County Fair in Middletown, New York. The old Grange Hall still stands on New York State Route 17K, near the intersection of New York State Route 302. (Courtesy of Louis Roberson.)

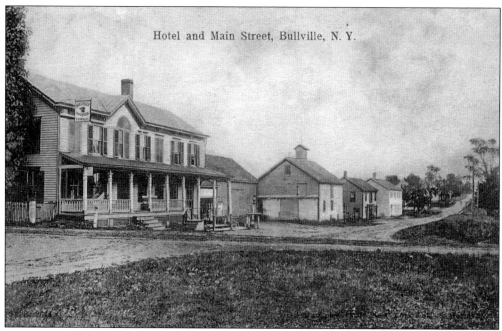

Hotel and Main Street, Bullville, N. Y.

In the early 1900s, the Dickerson Hotel was owned by F. P. Mills. At this time, it was called the Bullville Hotel. The Bullville Grange Hall stands in the distant background. (Courtesy Louis Roberson.)

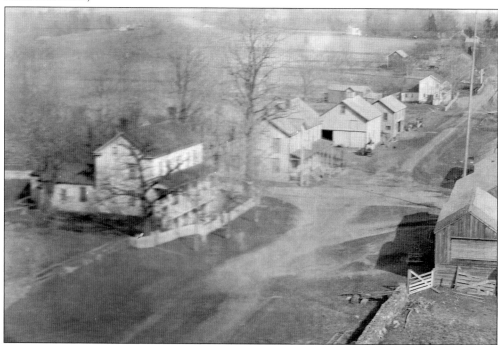

This 1898 bird's-eye view of Bullville was taken from the steeple of the Bullville Methodist Episcopal Church. The road is New York State Route 17K, and the buildings are, from left to right, the Old Homestead Hotel and Bar, the Dickerson Hotel, a barn, the G. McKney Blacksmith Shop, and in the distance St. Paul's Roman Catholic Church. (Courtesy of Louis Roberson.)

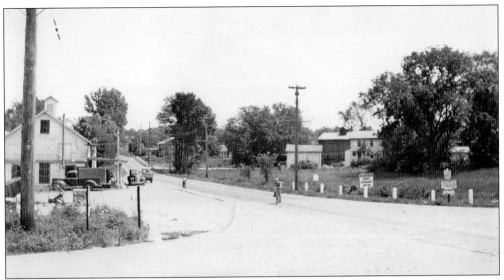

This 1940s photograph shows New York State Route 17K from the back of the Old Homestead Hotel and Bar. The sign in the middle says, "Newburgh Ferry Straight Ahead." New York State Route 17K was originally known as the Newburgh to Cochecton Turnpike, a toll road. (Courtesy of John Huntoon.)

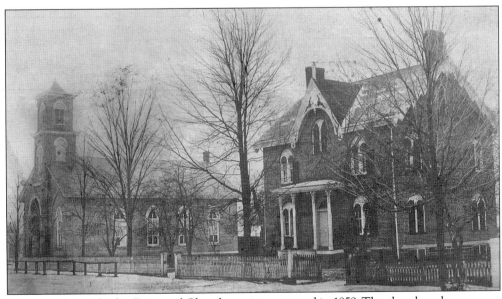

The Bullville Methodist Episcopal Church was incorporated in 1859. The church and parsonage, as seen in this 1898 photograph, are constructed of brick and still stand today. The cost in 1860 to build the two structures, on land donated by Mary Shorter, was $17,000. (Courtesy of Louis Roberson.)

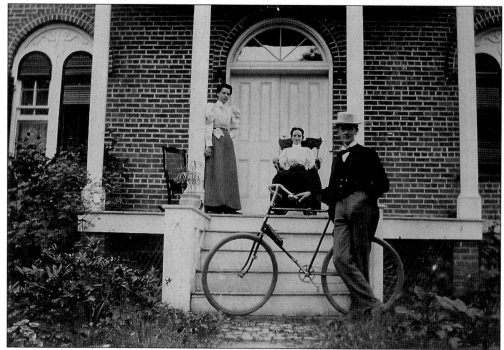

The Reverend William Thompson was the pastor of the Bullville Methodist Episcopal Church from 1897 until 1899. Joined by his wife and daughter in this 1898 photograph, Pastor Thompson leans on his reliable transportation on the front porch of the parsonage. In 1939, the name of the church was officially changed to Bullville Methodist Church. (Courtesy of Louis Roberson.)

This is the inside of the Bullville Methodist Episcopal Church on Children's Day in 1898. Over the years, the church has been affiliated with other local Methodist churches. In 1940, a pulpit and four pulpit chairs were donated to the church when the Burlingham Methodist Church closed. The pulpit and chairs remain today. (Courtesy of Louis Roberson.)

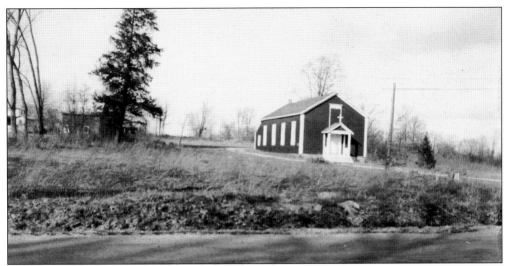

Built around 1865, St. Paul's Roman Catholic Church on New York State Route 17K in Bullville started as a mission of St. Joseph's Church in Middletown. According to a local priest, many Irish Catholic immigrants gathered in private homes to worship before this church was built. (Courtesy of Deacon John Frohbose.)

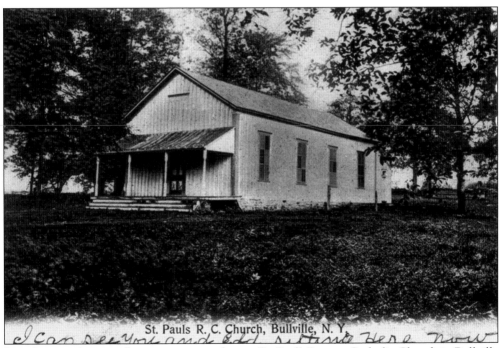

In order to make room for a growing population, St. Paul's Roman Catholic Church in Bullville added a new foyer, baptistery, and a choir area in 1952. This turn-of-the-20th-century postcard shows the church in its original configuration. (Courtesy of R. J. Smith.)

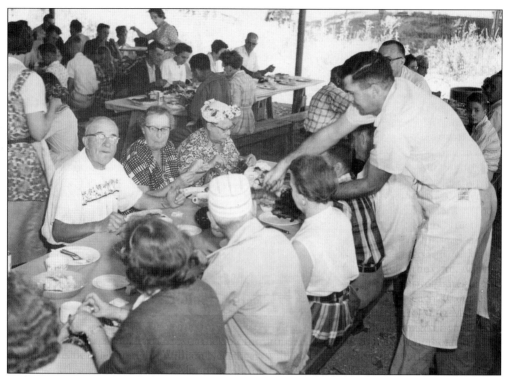

Benjamin Lambach serves congregants of St. Paul's Roman Catholic Church in Bullville during the first Corn Roast in 1959. (Courtesy of Deacon John Frohbose.)

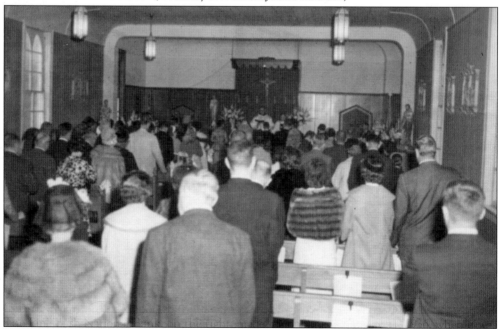

The wedding of John Ballmann and Ann Frobose on October 6, 1962, was the last wedding to occur in the original church. Several weeks later, a fire consumed the century-old structure. (Courtesy of Deacon John Frohbose.)

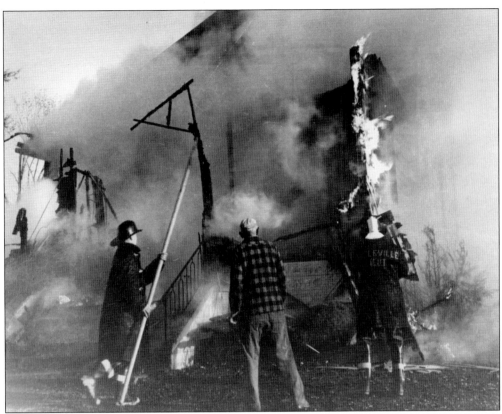

On October 29, 1962, a child lit a candle and accidentally dropped it into a garbage can of paper, and the church was destroyed by the fire. Church member and Circleville fireman Felix Kuczkowski is seen (center) helping to put out the fire. (Courtesy of Deacon John Frohbose.)

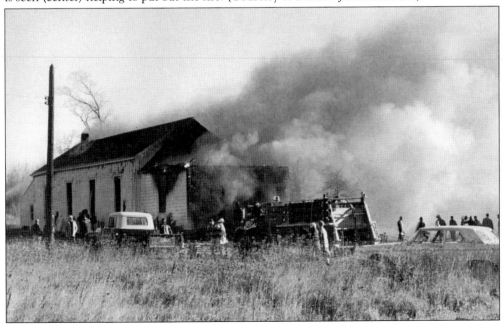

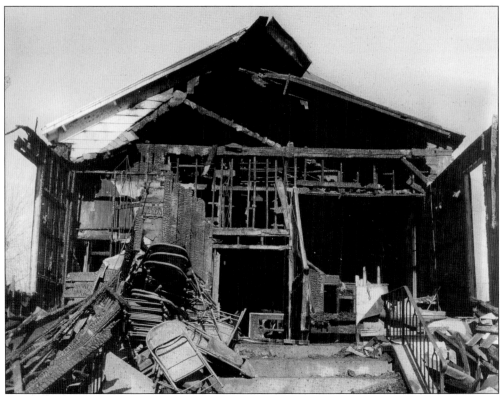

The remains of St. Paul's Roman Catholic Church in Bullville after the October 29, 1962, fire are displayed here. While the new church was being constructed, mass was held at Townley Hall in Circleville and then Our Lady of Assumption in Bloomingburg. (Courtesy of Deacon John Frohbose.)

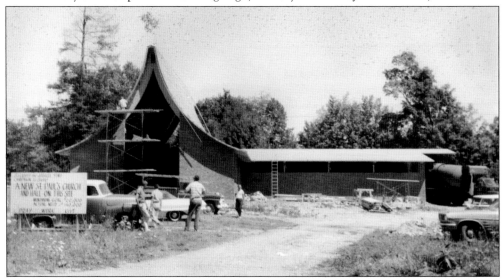

July 20, 1964, marked the raising of the roof on the new St. Paul's Roman Catholic Church in Bullville. A builder's tradition is to attach a branch to the peak of the roof, as seen in this photograph. The first service in the new church was Easter Sunday, April 18, 1965. (Courtesy of Deacon John Frohbose.)

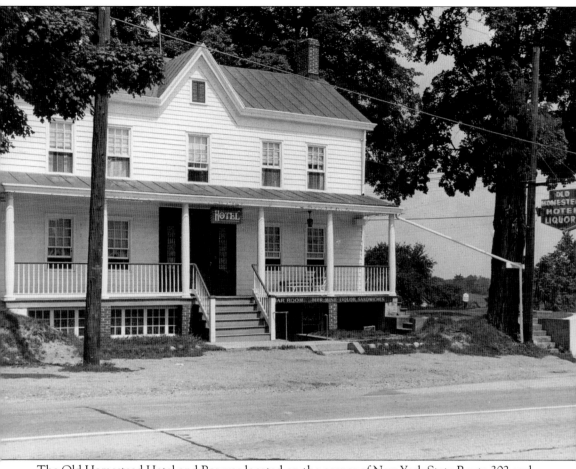

The Old Homestead Hotel and Bar was located on the corner of New York State Route 302 and New York State Route 17K in Bullville. Originally owned by members of the Roberson family, Phoebe Huntoon inherited it in the 1940s. It was known by local residents as "Phoebe's Bar." It burned in 1961. (Courtesy of John Huntoon.)

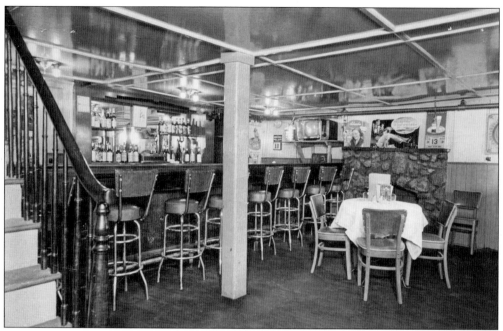

The Old Homestead Hotel and Bar served drinks at a pub located in the basement. The establishment had a unique license that allowed it to serve alcohol and also to sell bottled liquor over the counter like a liquor store. (Courtesy of John Huntoon.)

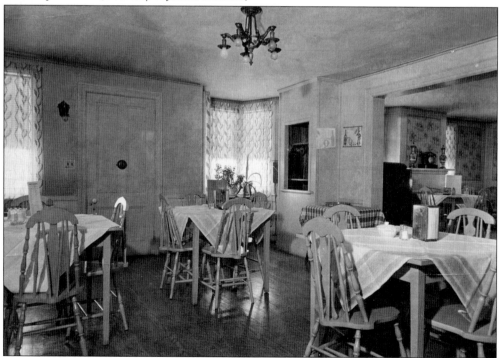

The dining room of the Old Homestead Hotel and Bar was located the first floor. After the 1961 fire that the destroyed the hotel, the Huntoons built an ice cream stand on this location. Today, in 2009, it is a pizzeria. (Courtesy of John Huntoon.)

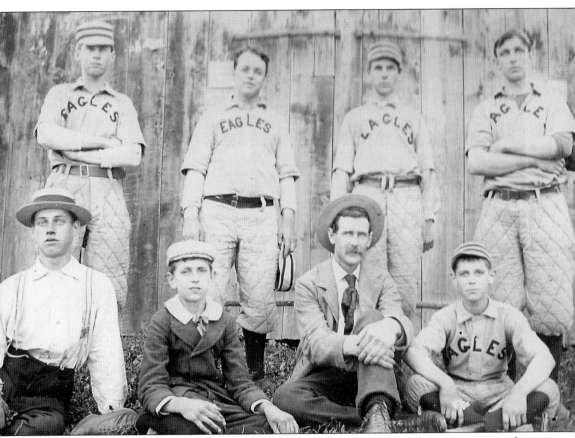

This is an 1898 photograph of the Bullville Baseball Club Eagles after their victory over the Ulsterville Baseball Club. The Eagles played on a field on New York State Route 302 between Jukas Stables and Burlingham Road. (Courtesy of Louis Roberson.)

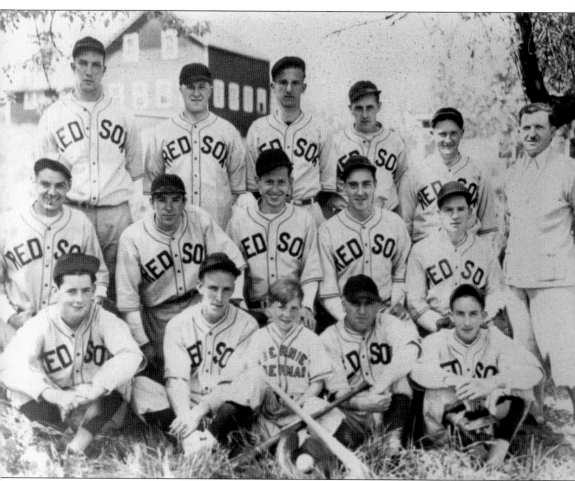

The Bullville Red Sox baseball team in this *c.* 1930 photograph played behind John Lunney's garage in Bullville. From left to right are (first row) James Freehill, Virgil Terry, Robert Whitman, Claude Cooper, and Kenneth Ovens; (second row) Frank Gesualdo, Arthur "Ox" Cooper, Larry Freehill, Warren Roberson, and Kenneth Cooper; (third row) Robert Wendland, "Corny" Randall, Al Barthel, Seely Lawrence, Lloyd Creeden, and coach Doug Pyle. (Courtesy of Joan Roberson Warren.)

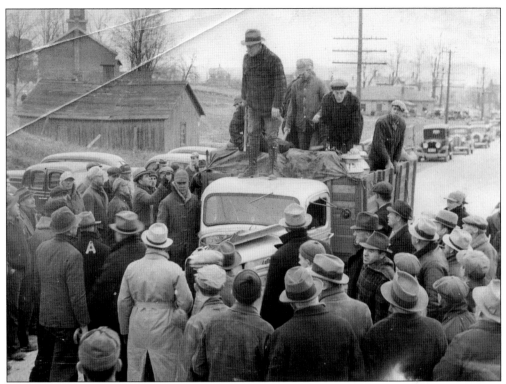

In 1939, local farmers went on strike and dumped their milk in protest of low milk prices. This photograph was taken on New York State Route 302 near the creamery. The Bullville Methodist Church is seen in the background. (Courtesy of Louis Roberson.)

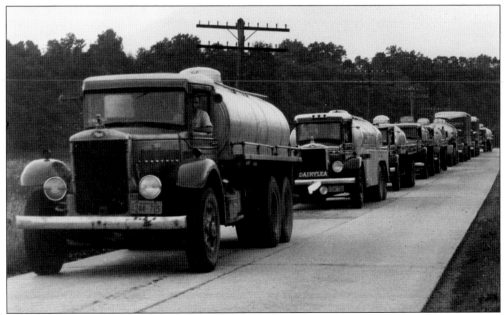

A long line of milk trucks is seen in this 1939 photograph of the Bullville Milk Strike. (Courtesy of Louis Roberson.)

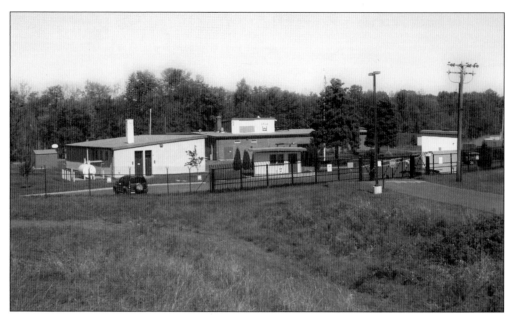

The Staff Sergeant Frederick J. Ill United States Army Reserve Center in Bullville is home of the 417th engineer company of the U.S. Army. Built around 1948 as a communication relay station on 182 acres in Bullville, it housed as many as 50 troops and operated 24 hours a day during the cold war. Frederick J. Ill Jr., who was also a captain in the New York City Fire Department, died on September 11, 2001, in the attack on the World Trade Center. The base is named in his memory. (Photographs by Fritz Meier.)

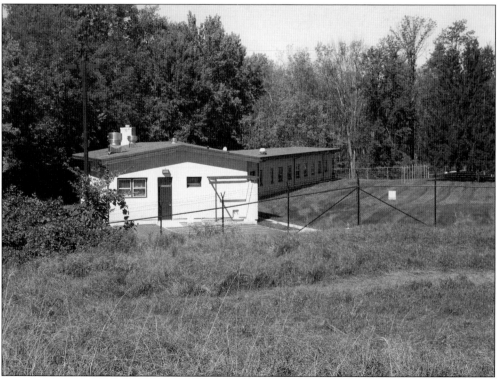

Four

PINE BUSH

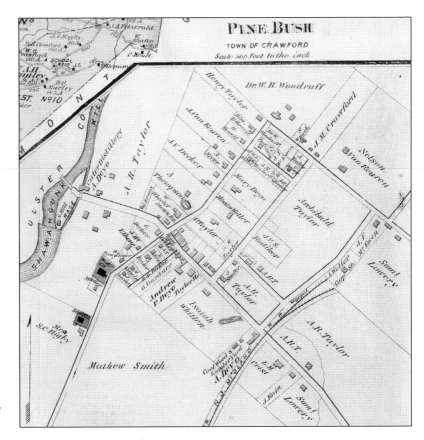

The 1875
Beers Atlas of
Orange County
contained this
map of Pine
Bush. (Courtesy
of Fritz Meier.)

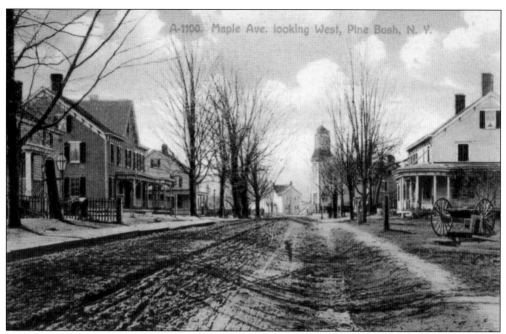

This 1900s view of New York State Route 302 shows when it was a dirt road leading into Pine Bush. The Pine Bush Methodist Church is seen in the background. (Courtesy of Fritz Meier.)

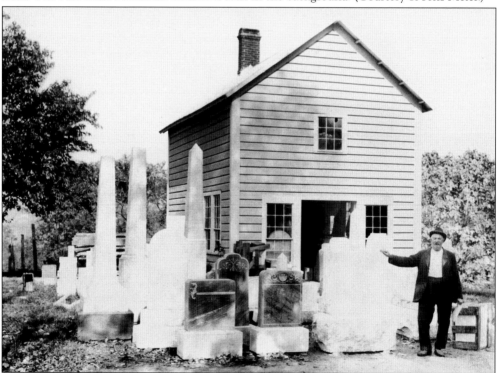

Billings Memorials is the oldest continuously run business in the town of Crawford. Established in 1880 by Ethelbert Billings, it remains open at the same location on New York State Route 302 in Pine Bush. Ethelbert Billings is seen in this *c.* 1915 photograph. (Courtesy of Jarred Russell.)

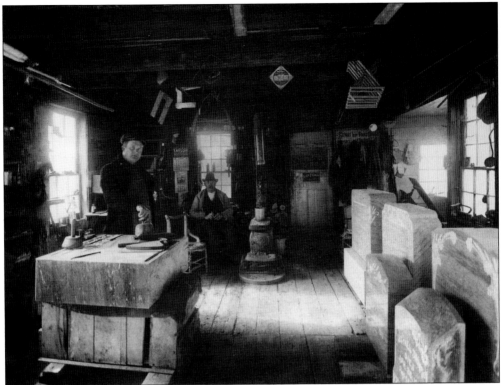

This 1915 photograph shows the interior of the Billings Memorials shop. Ethelbert Billings is seated and his son Elias Billings is standing to the left. Edward Joseph Russell bought the business from the Billings family, and it is now owned by his son Jarred Russell and Erik Pierson. (Courtesy of Jarred Russell.)

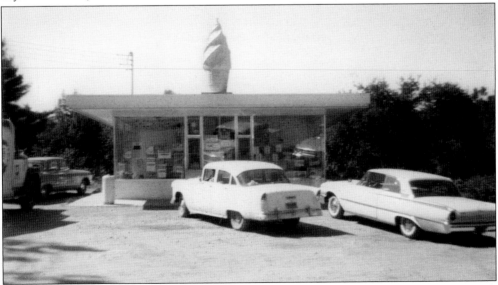

The Thorndale Dairy Bar was built in 1960 by Jack and Myrtle Thorn on the corner of New York State Route 302 and New York State Route 52 in Pine Bush. Many Pine Bush little leaguers have celebrated hitting home runs at this establishment. (Courtesy of Arthur and Kevin Kelly.)

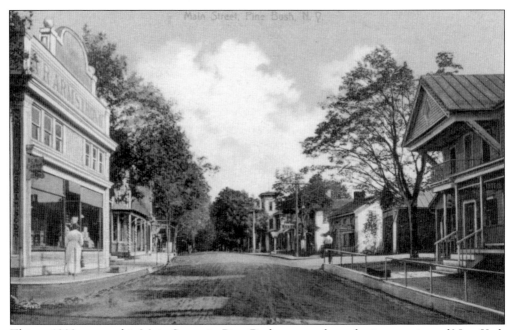

This *c.* 1900 postcard is Main Street in Pine Bush as seen from the intersection of New York State Route 302 heading toward Walden. A. R. Armstrong Pharmacy is on the left. The Decker House on the right no longer stands. (Courtesy of Pine Bush Area Library.)

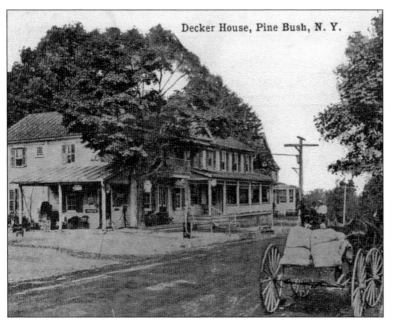

The Hiawatha House, also known as the Decker House, was a popular destination in the town. With its central location at the intersection of New York State Route 302 and New York State Route 52, it relied on the Middletown and Crawford Railroad to bring visitors to the area. (Courtesy of Pine Bush Area Library.)

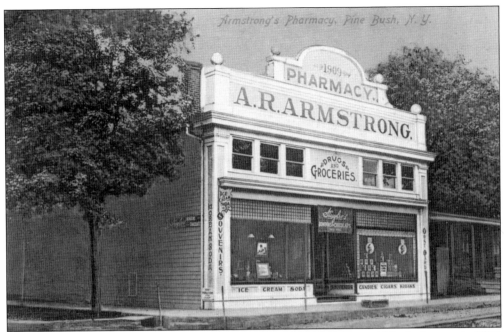

A. R. Armstrong's Pharmacy was built on the corner of Main Street and Maple Avenue in 1909. (Courtesy of Fritz Meier.)

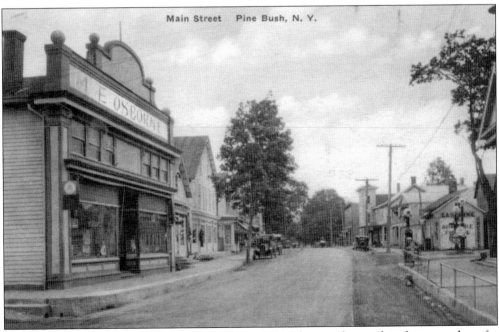

A. R. Armstrong's Pharmacy was sold to Maynard E. Osborne who ran his pharmacy there for many years. After changing hands several times, it is now owned by Richard and Allison Blazeski. Allison Watkins-Blazeski owns and operates her business, Hearts and Flowers Florist, in this building. Richard is the great grandson of Maynard E. Osborne. (Courtesy of Fritz Meier.)

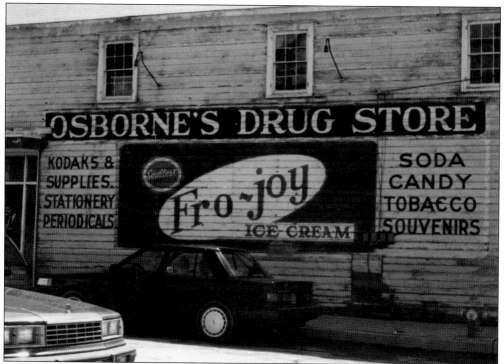

This large billboard sign was discovered under the siding of Hearts and Flowers Florist on the corner of Main Street and Maple Avenue. The building was once Osborne's Drug Store, and this billboard was originally to the right of the structure when looking at it from the front. (Courtesy of Douglas Rockwell Sr.)

The Just-a-Mere Shop owned by Vernooy and Seybolt was on the corner of Main Street and Maple Avenue. W. Wheeler had a store here in the 1870s; his shop housed the U.S. Post Office at that time. The building was demolished in the early 1970s. (Courtesy of Fritz Meier.)

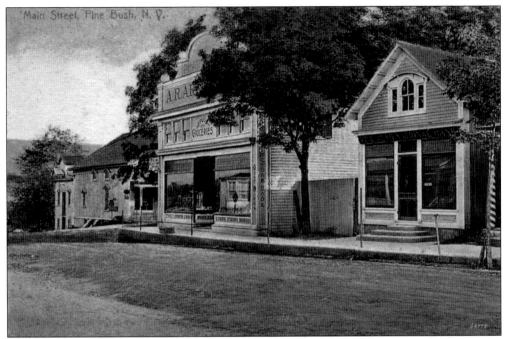

This *c.* 1912 postcard captures the newly constructed Pine Bush National Bank (right), Armstrong's Pharmacy (center), and Vernooy and Seybolt's Just-a-Mere Shop (left). Main Street (New York State Route 52) is seen in the foreground. (Courtesy of Louis Roberson.)

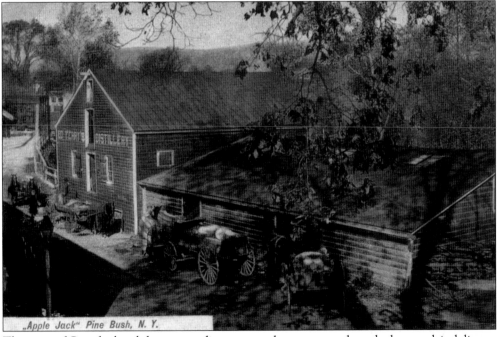

The town of Crawford and the surrounding area was known to produce the best applejack liquor. Ed Terry's distillery was located along the Shawangunk Kill and utilized waterpower from the river. The distillery's foundation can still be seen from the New York State Route 52 bridge that crosses the river near Pine Bush. (Courtesy of R. J. Smith.)

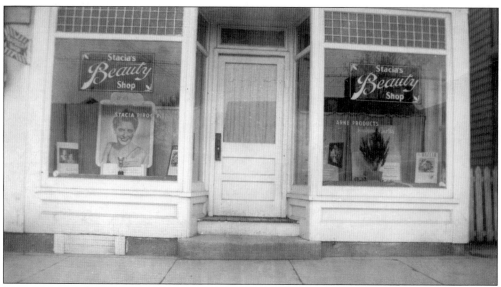

Stacia's Beauty Shop was located on Main Street midway between Chessari's Market and Osbourne's Pharmacy from 1940 through 1947. It was opened by Stacia Pirog who, in 1947, married Eugene Kelley, the namesake of the Eugene Kelley Catholic War Veterans Post in Pine Bush. Pirog moved her shop to behind her house on Charles Street. (Courtesy of Stacia Pirog Kelley.)

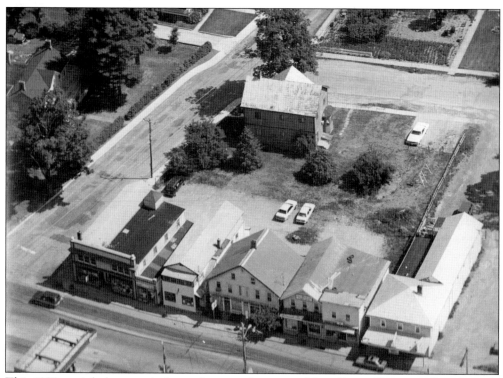

This 1980s aerial photograph shows the row of stores on Main Street (foreground) and Maple Avenue (left). The building to the right, which is now the Sneakers to Boots store was once Chasseri's Market and Ribbecke's Butcher Shop. (Courtesy of Allison Watkins-Blazeski.)

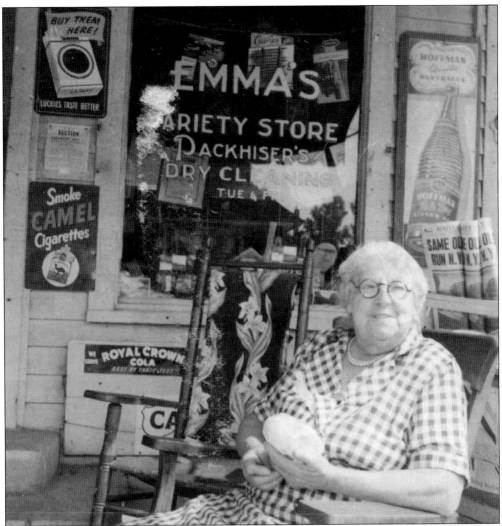

Emma's Variety Store—shown here in this *c.* 1940 photograph—was owned by Emma Coddington and located on Main Street on what is now the parking lot next to the Sneakers to Boots shoe store. Many area residents remember Emma's fine selection of penny candy. (Courtesy of Betty Rumpf Moorehead.)

The Falconer Inn on New York State Route 302 in Pine Bush is a Greek Revival period house built in 1840, and it is one of the earliest homes in Pine Bush. Originally owned by James Taylor, it then passed to James Corwin, and in 1882, Arminda Falconer opened it as an inn. The current owners, Richard and Deborah Triggiani, placed the inn on the National Register of Historic Places. (Photograph by Fritz Meier.)

The Heronamus Weller house on Maple Avenue has been continuously occupied by his family since 1806. Weller helped in the organization of the town of Crawford in 1823 and served as one of the three commissioners of its district schools. This house is owned by Richard "R. J." Smith and his wife, Elizabeth "Liz" Boniface Smith. (Photograph by Fritz Meier.)

This 1910 postcard shows the residence of Archibald Taylor. This house was built in 1904 and is located on Maple Avenue next to the Pine Bush Area Library. It is now owned by Mark and Barbara Grey who operate the Pine Bush House Bed and Breakfast in this stately residence. (Courtesy of Fritz Meier.)

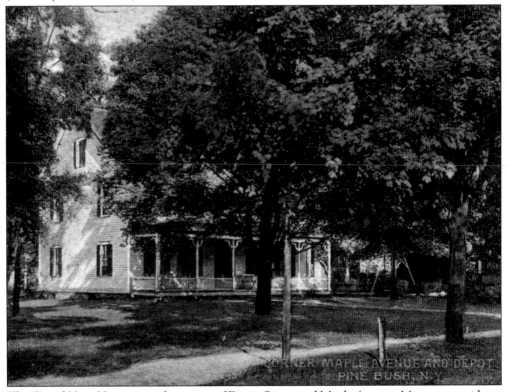

The Grand View House is on the corner of Depot Street and Maple Avenue. Many area residents turned their homes into rooming houses to accommodate tourists that came to town by train. (Courtesy of Pine Bush Area Library.)

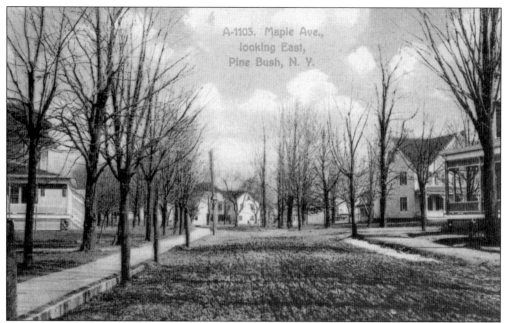

This is a turn-of-the-20th-century postcard that shows Maple Avenue as seen from Main Street. The Grand View House is seen on the right. Maple Avenue may have gotten its name from the maple trees that lined the street and offered a canopy of leaves in the summertime. (Courtesy of Pine Bush Area Library.)

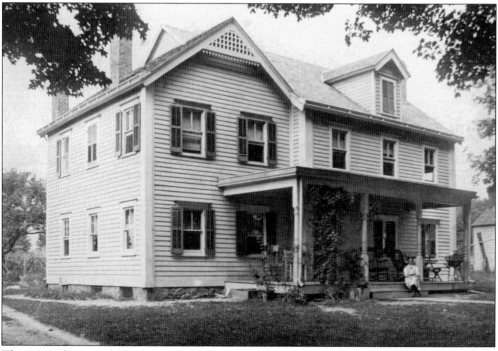

This 1910 photograph shows Maple Hall, which was a rooming house on Maple Avenue near the intersection of Charles Street. It is now the home of Roger and Claudia Kelso. (Courtesy of Roger Kelso.)

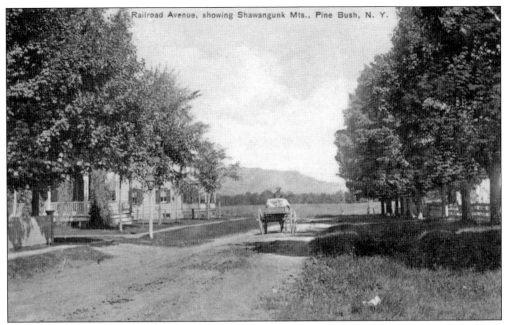

This turn-of-the-20th-century postcard shows how the land beyond North Street in Pine Bush was open farmland. Railroad Avenue now crosses North Street and becomes Mountain View Avenue, and houses now occupy this field. (Courtesy of Fritz Meier.)

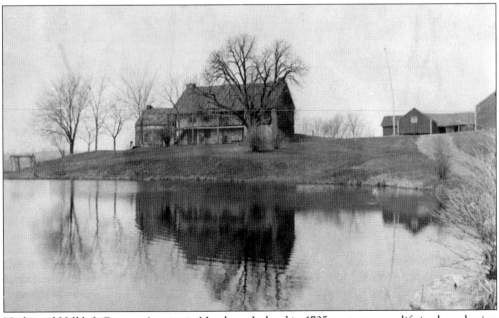

Nathaniel Hill left County Antrim in Northern Ireland in 1735 to start a new life in the colonies. This 1934 photograph shows the farm that he built in the town of Crawford around 1835–1840 on 800 acres. Located on Hill Avenue, this property has been in the Hill family since 1735. (Courtesy of Robert Adams.)

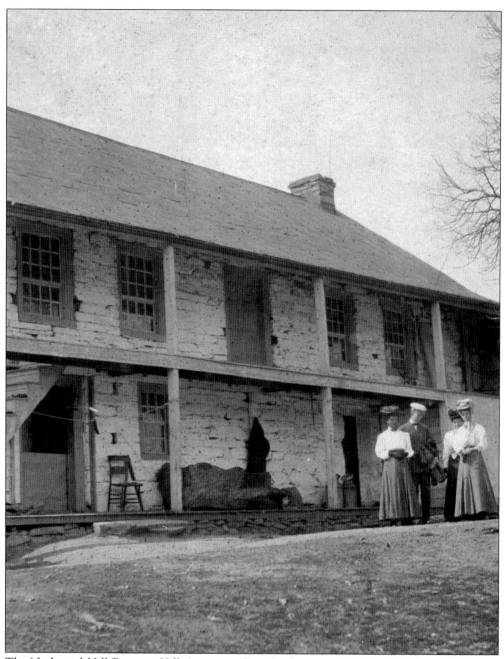

The Nathaniel Hill Farm on Hill Avenue in Pine Bush is seen in this 1909 photograph. The property once had many outbuildings, two of which still stand today. The Hill family produced applejack liquor in the 1800s in a distillery on the farm. (Courtesy of Bob Adams.)

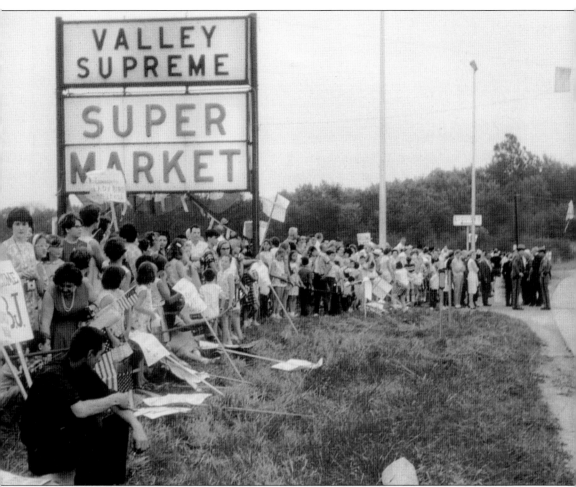

August 19, 1966, was a historic day in Pine Bush. U.S. president Lyndon B. Johnson and his wife, Lady Byrd, stopped in Pine Bush to greet the townspeople. The president and his wife were on their way to Ellenville to dedicate the Ellenville Hospital. The residents of Pine Bush lined the streets in front of the Valley Supreme Super Market, owned by Arthur Moriano, to greet U.S. president Lyndon Johnson and his wife. Accompanying the president were U.S. senators Jacob Javits and Robert F. Kennedy. Congressman John G. Dow and Joseph Y. Resnick were also present. (Courtesy of Robert Bender.)

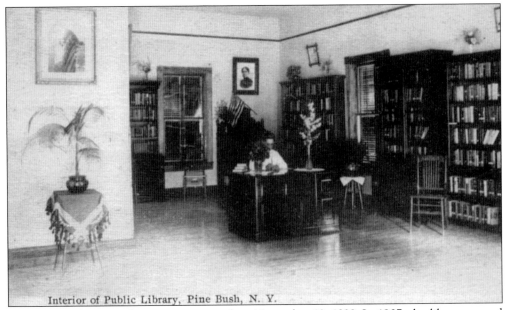

Interior of Public Library, Pine Bush, N. Y.

The Pine Bush Area Library was organized on November 10, 1899. In 1907, the library moved into its present location on Maple Avenue. Mrs. Joel Whitten was the first librarian and is seen sitting at her desk in this *c.* 1907 postcard. (Courtesy of Louis Roberson.)

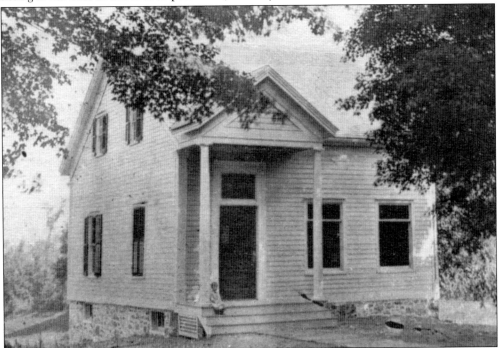

The Pine Bush Area Library was incorporated on December 21, 1899, and received its permanent charter on December 1, 1904. H. R. Taylor, who owned one of the local lumberyards, donated a building to the library that was remodeled. The reconstruction and remodeling was supervised by H. J. McKinney, the president of the library. This 1920s postcard shows the new library that opened in the summer of 1907. (Courtesy of Pine Bush Area Library.)

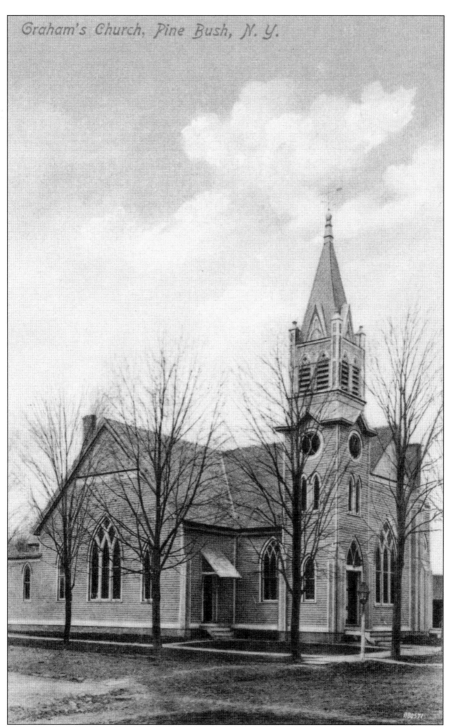

Graham's Church, Pine Bush, N. Y.

The Graham's Presbyterian Church, located at the corner of Depot Street and New Street, was built in 1888. The original church was founded by Robert Graham in 1799 and was located on Hill Avenue on land donated by Abraham Dickerson. The Graham's Church Cemetery marks the spot of the original church. (Courtesy of Pine Bush Area Library.)

This is another view of Graham's Presbyterian Church in Pine Bush as seen from Depot Street. The building to the right no longer stands. (Courtesy of Pine Bush Area Library.)

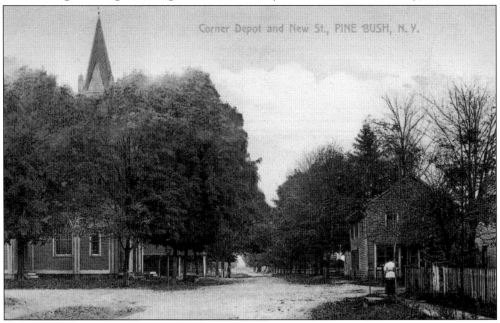

This c. 1900 postcard shows New Street at the intersection of Depot Street. The Graham's Presbyterian Church is located on the left. (Courtesy of Fritz Meier.)

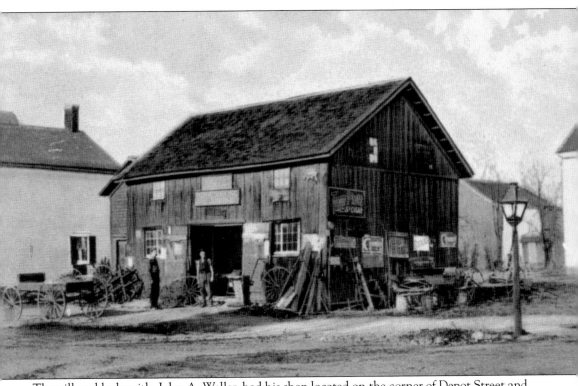

The village blacksmith, John A. Weller, had his shop located on the corner of Depot Street and New Street, across from Graham's Presbyterian Church. In the early part of the 20th century, local schoolboys borrowed a horse buggy from this shop and carefully reassembled it on the ridge of the District No. 3 schoolhouse in Pine Bush as a joke. (Courtesy of Fritz Meier.)

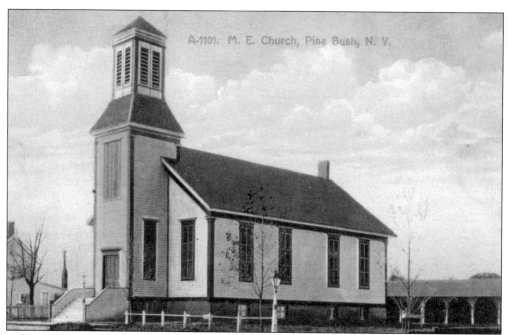

The Methodist Episcopal Church of Pine Bush was built in 1871. The carriage shed behind the church served as a place for parishioners to keep their horse and buggy during Sunday morning services. The church parsonage was later added to the right of the church. (Courtesy of Fritz Meier.)

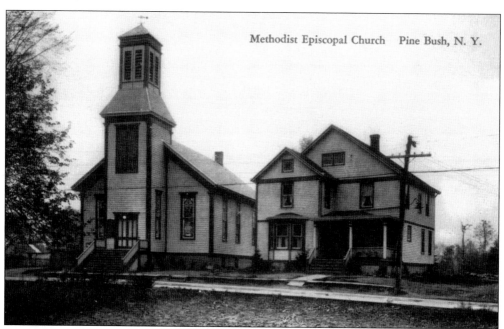

During the 1979 Iranian hostage crisis, the church bell was rung to mark every day that the hostages were held captive. On the last day of their captivity, the bell tolled 444 times. The author remembers having permission to leave Crispell Middle School next door to help classmate Timothy Foote ring the bell. (Courtesy of R. J. Smith.)

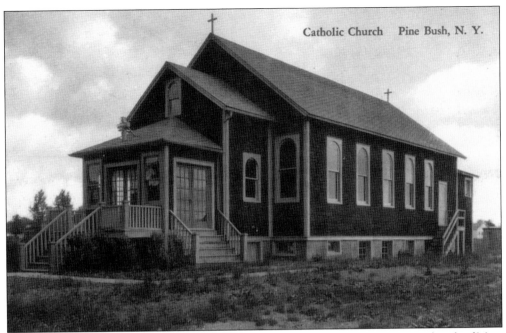

The Church of the Infant Savior, which is Roman Catholic, was built as a mission church of Most Precious Blood Roman Catholic Church in Walden, New York. It was built in 1926 and became a parish in 1951. In 1960, it was razed to make way for the current church building. (Courtesy of R. J. Smith.)

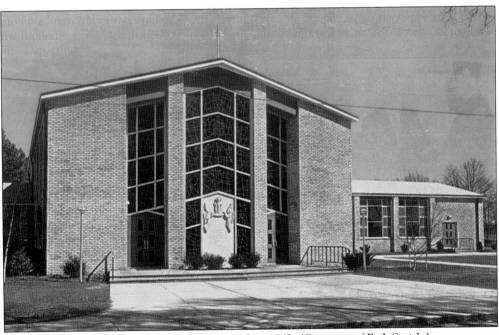

The Church of the Infant Savior was dedicated in 1962. (Courtesy of R. J. Smith.)

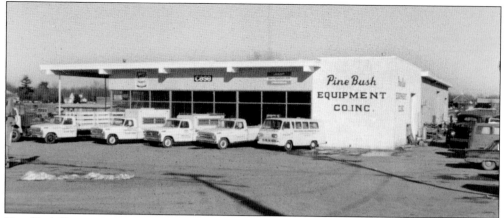

Pine Bush Equipment was started by Edward "Ted" Boniface and his wife, Dorothy Goldsmith Boniface, in 1956. This early 1970s photograph shows some of Pine Bush Equipment's truck fleet. (Courtesy of Pine Bush Equipment.)

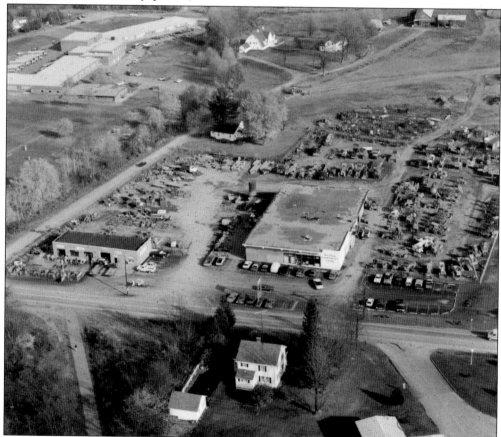

Pine Bush Equipment's entire yard and stock can be seen in this early 1980s aerial photograph. Edward J. Russell Elementary School is in the top left corner. The road along the left side, Stock Market Drive, is named after the Livestock Market in the upper right corner of this photograph. Presently, Stock Market Drive continues on as Boniface Drive connecting with New York State Route 52. (Courtesy of Pine Bush Equipment.)

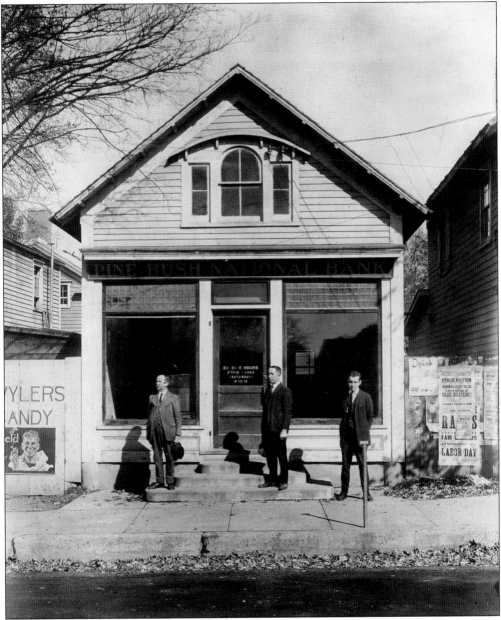

The Pine Bush National Bank, established in 1911, was located on Main Street near the intersection of New York State Route 302. This photograph was taken in 1915. (Courtesy of Louis Roberson.)

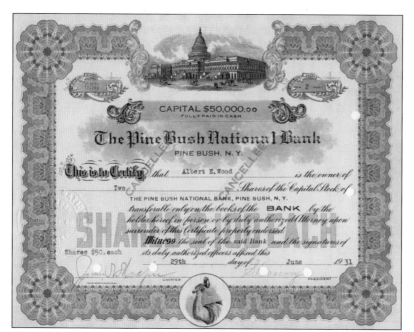

The Pine Bush National Bank was founded in 1911. Its first Main Street Branch was close to the New York State Route 302 intersection. When it outgrew that building, the bank moved to the corner of New Street and Main Street. This stock certificate for the bank was for two shares at $50 each. (Courtesy of Fritz Meier.)

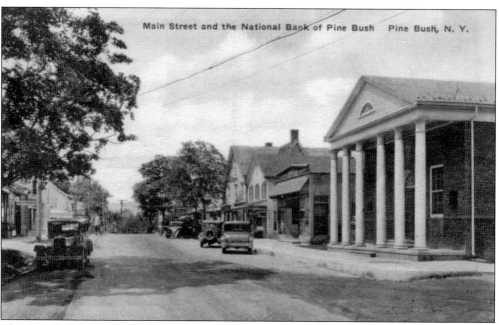

The Pine Bush National Bank, on the right, made regional news on May 11, 1936, when it was robbed by five men. The bandits got away with about $14,000. After a two-day chase, four of the men were apprehended in Otisville, New York; the fifth man turned the gun on himself to end his life. (Courtesy of Fritz Meier.)

France Motors was a Chevrolet car dealership in Pine Bush. It was located on the corner of Main Street and New Street. A gas station and pizzeria now occupy this space. (Courtesy of Eric Palazolo.)

Across the street from the railroad station on Depot Street was Hay's Hotel. Most area residents now know this as Hermann's Erie Hotel. It is named after Hermann Reuter, father of the current owner Robert Reuter and his wife, Loretta. (Courtesy of Pine Bush Area Library.)

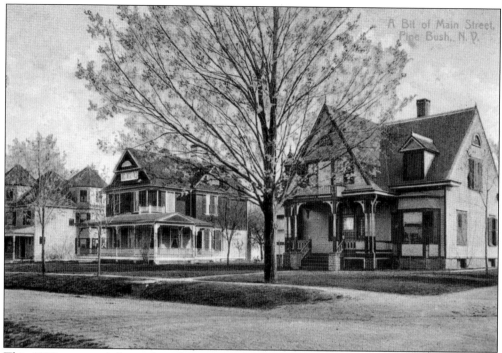

This 1920s postcard shows three houses on Main Street, which still stand today. The house on the left is currently the office of Mercurio, Norton, and Tarolli; the house in the center is vacant; and the house to the right is the Capt. Dayton Decker house built in 1903. It is the office of R. J. Smith Real Estate Solutions. (Courtesy of Pine Bush Area Library.)

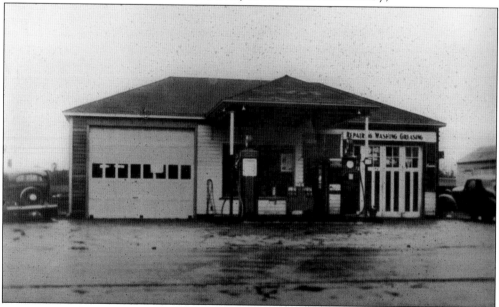

Started by Hanford Youngs in the 1930s, Youngs Service Station has been owned and operated by three generations of the Youngs family through 2009. The fourth generation member of the family, Kevin, now works there also. In addition to the garage, Hanford Youngs also owned a Chrysler-Plymouth dealership. (Courtesy of Kevin Youngs.)

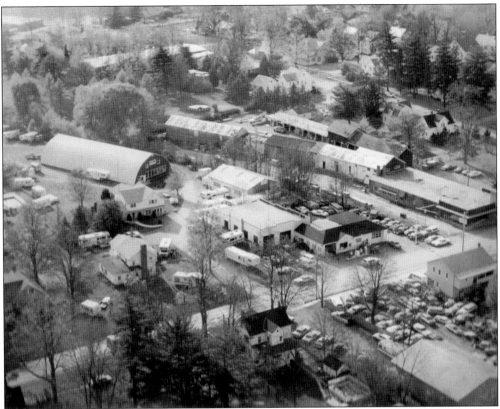

This 1970s aerial photograph shows Youngs Service Station in the center and Conklin's Lumber Yard to the right, where the present-day—2009—U.S. Post Office is located. The road that goes left to right is New York State Route 52. (Courtesy of Kevin Youngs.)

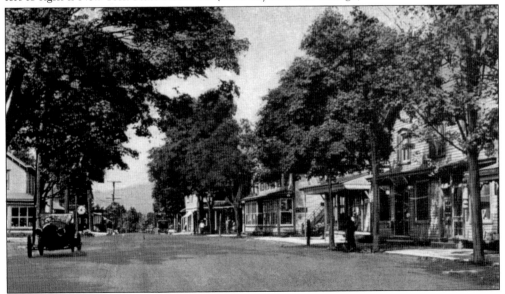

It is hard to imagine a tree-lined Main Street in Pine Bush as seen in this 1920s postcard. (Courtesy of Fritz Meier.)

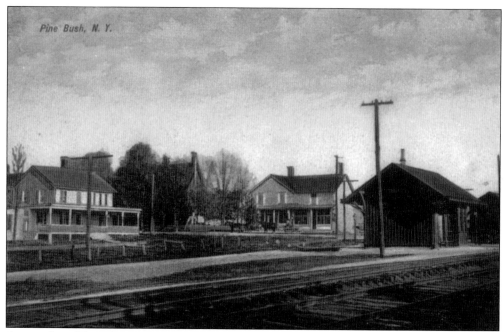

Pine Bush, N. Y.

A view from Main Street near the present location of Youngs Service Station shows the Pine Bush Train Station to the right. The Brown and Whitten store, center, was a general merchandise store. The Erie Hotel is located to the left. (Courtesy of Pine Bush Area Library.)

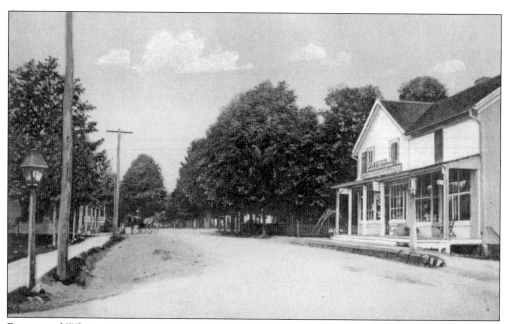

Brown and Whitten's store was a general merchandise store and carried anything from clothes to John Deere farming implements. It is still located on the corner of Railroad Avenue and Depot Street. (Courtesy of Fritz Meier.)

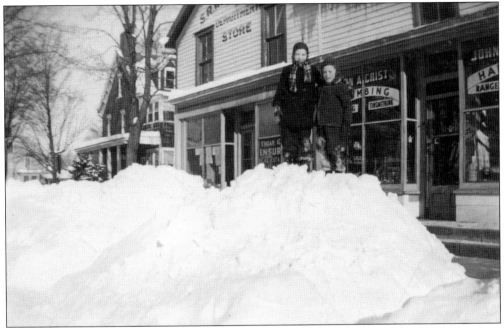

Elva Costello (left) and Douglas T. Rockwell Sr. (right) are standing on a snowbank outside of John A. Crist Plumbing in the winter of 1945. The building is located on the corner of Depot Street and Railroad Avenue and was once the S. R. Whitten Department Store. (Courtesy of Douglas Rockwell Sr.)

The Knights of Pythius Lodge No. 252, seen above in this c. 1915 photograph, was one of the biggest buildings in the town of Crawford. It was utilized by the school until 1941 to host basketball games, plays, and dances. The building also had two bowling lanes in the basement. The Eugene L. Kelley Post of the Catholic War Veterans now owns and occupies this building. (Courtesy of Pine Bush Area Library.)

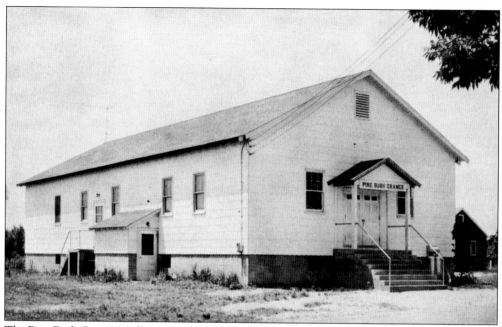

The Pine Bush Grange Hall, at the end of Kelly Avenue, hosted the Infant Savior Roman Catholic Church from 1961 to 1963 while the new church was being built. The Grange Hall is now Mark Vail Auctions. (Courtesy of Mark Vail.)

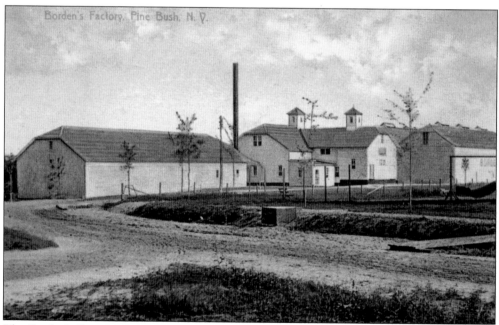

The Borden's Creamery was one of the biggest employers in the Pine Bush area. It employed around 70 people at its peak. The plant was located at the end of Borden Avenue. It closed around 1947, and the buildings were razed. The railroad track ran behind these buildings. (Courtesy of Fritz Meier.)

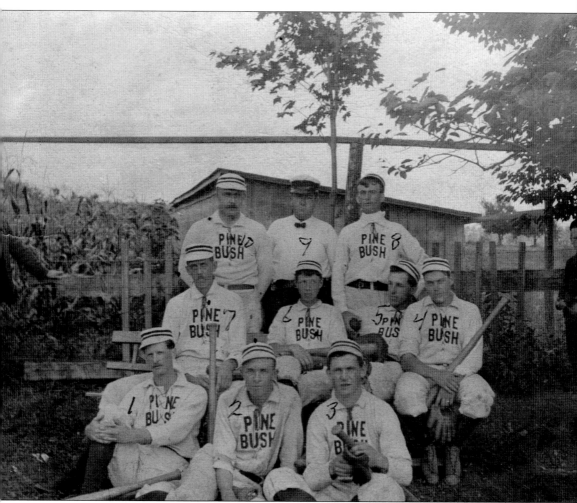

The Pine Bush Baseball Club is seen in this 1906 photograph. From left to right are (first row) Peter Decker, Elias Billings, and Key Signey; (second row) Alonzo Howell, Donald Mosker, Silas Dickerson, and Winifred Decker; (third row) Dr. Merritt, Jay Green, and Fred Kain. (Courtesy of George Low.)

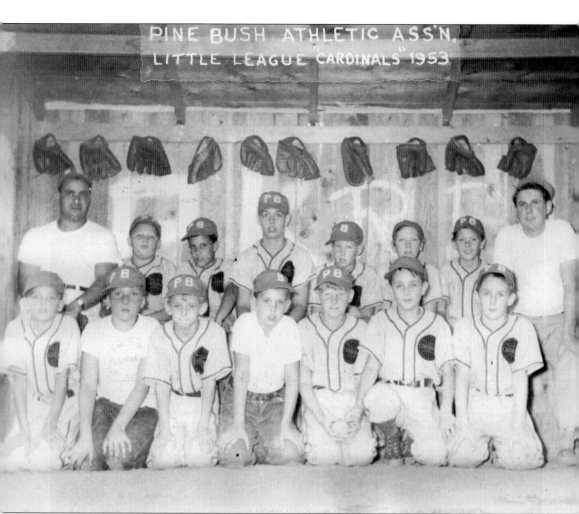

The second year for the Pine Bush Little League was 1953. This photograph shows the first place team, the Cardinals. From left to right are (first row) Lee Hardy, Henry Klein, Don Broad, Ken Youngblood, Phil Johanson, Art Fredrickson, and Henry Kelner; (second row) Isadore Stitch Wittenburg, Fred Hammer, Jeff Wittenberg, Joe Russell, Cliff Youngblood, John Stewart, Emmet Jones, and John Getler. (Courtesy of the Wittenberg family.)

New York State Route 52 has had several names throughout the years. This 1940s postcard shows the road just outside of Pine Bush going towards Walker Valley. It was built in 1851 as the Newburgh-Ellenville Plank Road. (Courtesy of Arthur and Kevin Kelly.)

The Hardenburgh Road Bridge over the Shawangunk Kill once had an optional path through the river water. This was needed to swell the wood on metal-rimmed, horse-drawn wagon wheels to keep the metal tight on the wheel. (Courtesy of Fritz Meier.)

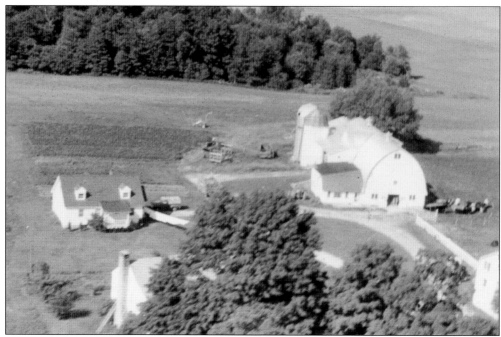

This 1969 aerial photograph shows Seldom Rest Farms, owned by the DeVries family. It is one of the few remaining active dairy farms in the town of Crawford. Once known as the "butter capital of the world," Crawford had dairy farms that were known for their high quality of milk produced by local dairy herds. (Courtesy of Henry DeVries.)

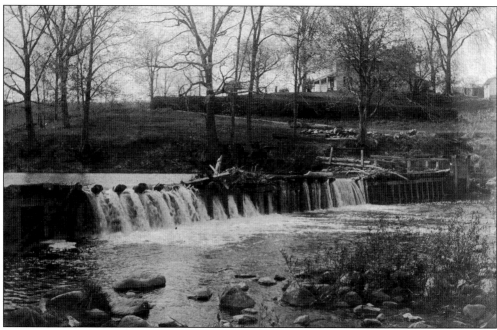

One of the many mills along the Shawangunk Kill was Bruyn's Grist Mill. This 1907 photograph shows the wooden dam built to harness the power of the river. It was located near the intersection of Bruyn Avenue and Crawford Street. (Courtesy of Donald Bruyn.)

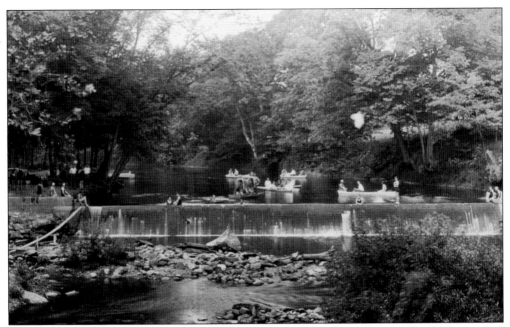

Shawangunk Lake, shown here around 1927, was formed when the dam by the old Bruyn mill was built. Boats could be rented, and people could swim in the slow waters of the lake. A baseball field nearby was the home of the Ulsterville Baseball Club. (Courtesy of Donald Bruyn.)

George Bruyn died in 1929 at the age of 98. George was a direct descendent of Jacobus Bruyn, one of the original patent holders in the region in 1709. George survived the sinking of the USS *Central America* in 1857 by casting off his belt with $2,000 in gold and swimming for 12 hours. (Courtesy of Donald Bruyn.)

After surviving the shipwreck of the USS *Central America*, George Bruyn came back home and built his farmhouse on Bruyn Avenue in 1862. This 1908 picture shows George and his wife, Susan, by their home on Bruyn Avenue. (Courtesy of Donald Bruyn.)

George Bruyn's son Robert G. Bruyn converted the front of the farmhouse into Bob's Bar and Grill in the 1940s. Robert's grandson Donald is standing on the front steps of the house in this *c.* 1940 photograph. (Courtesy of Donald Bruyn.)

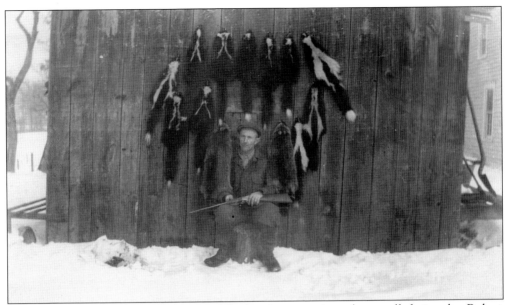

Local residents often hunted or trapped fur-bearing game in order to sell their pelts. Robert Bruyn poses with his 11 skunks and two raccoons in this *c.* 1910 photograph. (Courtesy of Donald Bruyn.)

Robert Bruyn's son Raymond is standing in the foreground in this *c.* 1920 photograph. Raymond would later become the town of Crawford highway superintendent and is credited with naming most of the town's back roads in the late 1950s. The names of the roads were often derived from the oldest family on the road. (Courtesy of Donald Bruyn.)

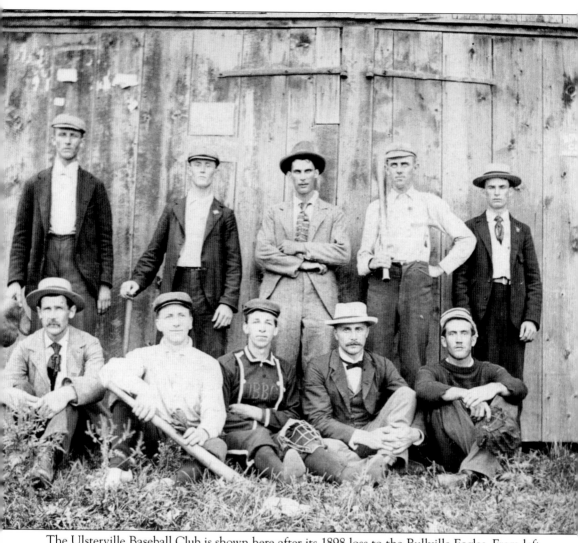

The Ulsterville Baseball Club is shown here after its 1898 loss to the Bullville Eagles. From left to right are (first row) Frank Dickerson, Leon Dickerson, S. Dickerson, Dr. Merritt, and George Bruyn; (second row) William Bruyn, Robert Bruyn, Bert Kain, William Rumsey, and Fred Kain. (Photograph by C. W. Roberson; courtesy of Donald Bruyn.)

Five

AROUND CRAWFORD

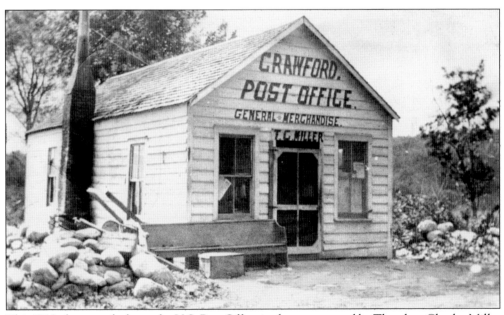

This 1910 photograph shows the U.S. Post Office in the store owned by Theodore Charles Miller in Crawford. This hamlet is often confused with the town of Crawford, but actually lies in the town of Shawangunk, near the intersection of Oregon Trail and Indian Springs Road. (Courtesy of Norman Miller.)

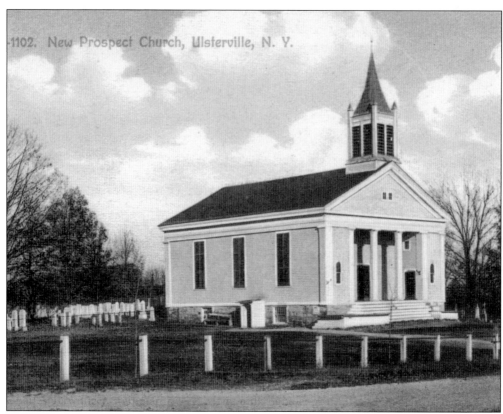

The New Prospect Reformed Church was formed in 1814 as part of the Shawangunk Dutch Reformed Church Consistory. In 1829, it severed its ties to the Shawangunk Consistory and was incorporated. The original church was razed and the present-day church was built from 1855 to 1856. The land was donated by Hazael VanKeuren. (Courtesy of Fritz Meier.)

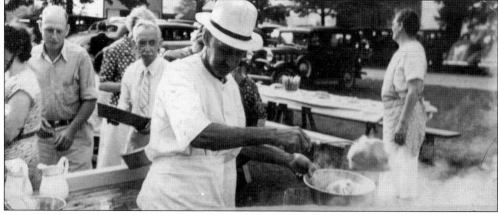

This 1936 photograph shows head cook Corwin Detch (center), Marjorie Anderson (right), John Watson (with tie), and Alvin McKaig (left) during a clambake at the church. The New Prospect Church Cemetery is the final resting place for many Pine Bush–area residents. (Courtesy of Roger Kelso.)

Judge James Gregston Greer IV is seen in this 1936 photograph from the New Prospect Church clambake. A lifelong resident of Walker Valley in the town of Shawangunk, Greer served on the Pine Bush Central School Board from 1955 until 1975. Judge Greer was also a town of Shawangunk justice from 1967 to 1993. Greer was known for saying, "It's a beautiful day in the country!" (Courtesy of Roger Kelso.)

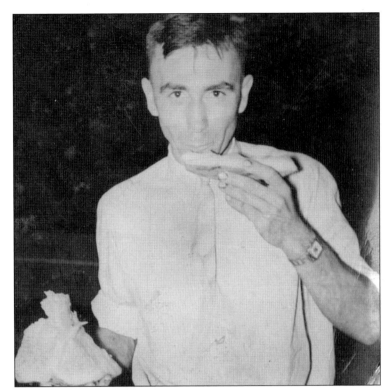

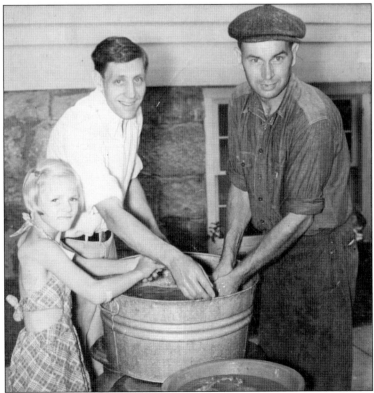

This 1936 photograph shows Rev. Willard Wullschleger, his daughter Jane (left), and Leo Kane (right) washing clams for a clambake at the New Prospect Reformed Church. (Courtesy of Roger Kelso.)

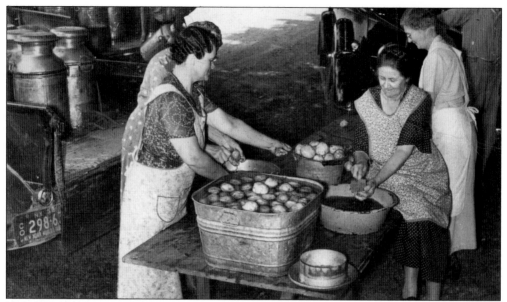

Mabel Boyce (sitting, right) helps clean potatoes in preparation for the 1936 oyster supper at the New Prospect Church. (Courtesy of Roger Kelso.)

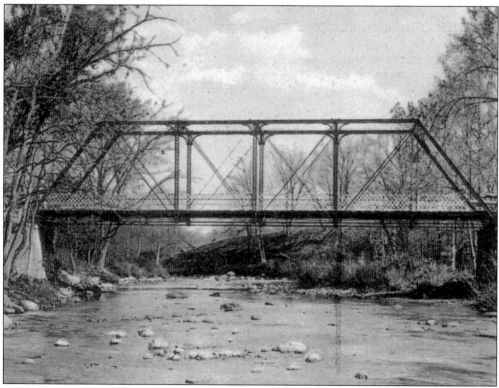

This c. 1910 postcard shows the bridge over the Shawangunk Kill in Pine Bush in its original location. The bridge was relocated about 100 yards downstream and elevated in order to make New York State Route 52 more flat. The recreation park would have been behind the photographer of this picture. (Courtesy of Pine Bush Area Library.)

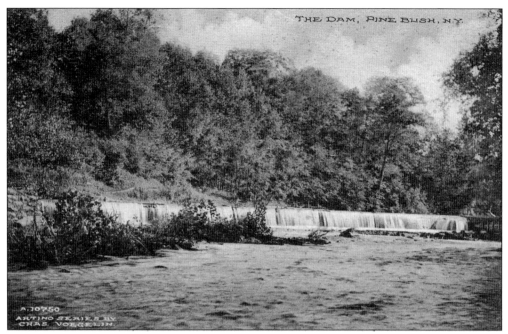

This 1914 postcard shows the dam built across the Shawangunk Kill, just upstream from the New York State Route 52 Bridge over the river. This dam, originally made of wood, was constructed to divert water to the lumber mill, gristmill, and distillery along the banks of the Shawangunk Kill at the base of Ribbecke Hill. (Courtesy of Fritz Meier.)

The foundation of this sawmill can still be seen along the banks of the Shawangunk Kill near the New York State Route 52 Bridge. It was powered by the river's water. (Courtesy of Fritz Meier.)

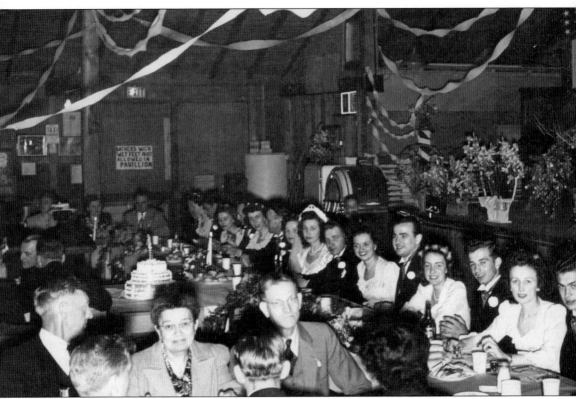

The recreation park, located just over the Ulster County line in the town of Shawangunk, had many activities for all ages. There were picnic spots, rowboats, swimming, and open areas for games. Many weddings, school functions, and parties were held there until it closed in the mid-1970s. This June 1, 1946, photograph shows the wedding reception of Eugene Kelley and Stacia Pirog in the main building. (Courtesy of Stacia Pirog Kelley.)

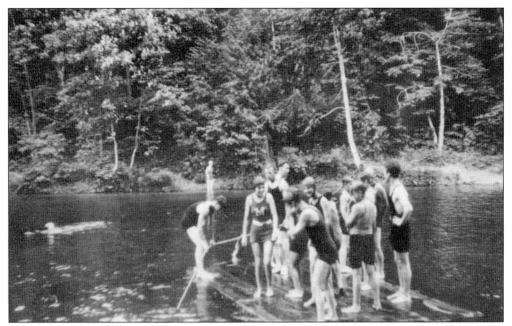

This area of slow water above the dam by the recreation park was utilized in the winter to harvest ice for the Borden's Creamery located at the end of Borden Avenue. A conveyor was used to drag the ice blocks up the steep banks behind the present-day Crispell Middle School. In the summer, it was a popular swimming spot. (Courtesy of Fritz Meier.)

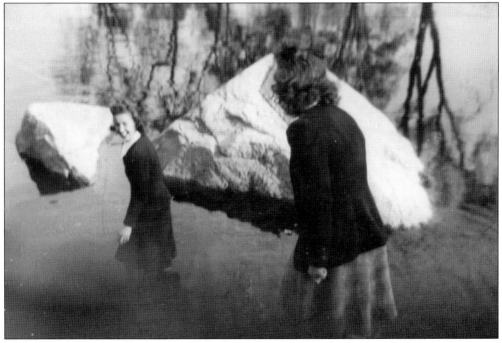

In the Shawangunk Kill, upstream from recreation park, was this large rock that was known as Jack's Rock. Stacia Pirog Kelley is wading near the rock in this c. 1935 photograph. It is unknown who Jack was and why this rock was named after him. (Courtesy of Stacia Pirog Kelley.)

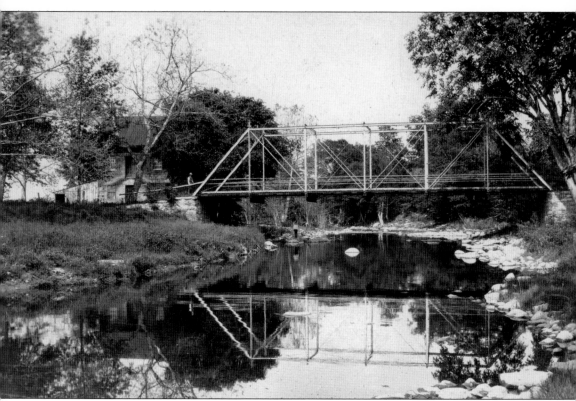

This turn-of-the-20th-century postcard was the bridge on Orange County Road 48 as it crosses over into Sullivan County. The building to the left was a gristmill, which used the river for power. The bridge was later moved several miles away off Burlingham Road by Edward Boniface. (Courtesy of Fritz Meier.)

Six

SERVICE ORGANIZATIONS

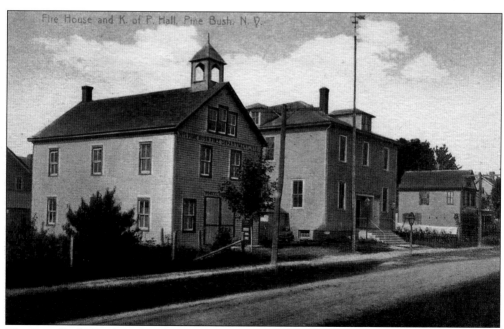

The Pine Bush Hook and Ladder Company was organized in 1906. Their first firehouse was completed by 1910 on Center Street and it is seen on the left in this *c.* 1915 postcard. Horses for the horse-drawn fire apparatus were located in a livery behind the firehouse. (Courtesy of Louis Roberson.)

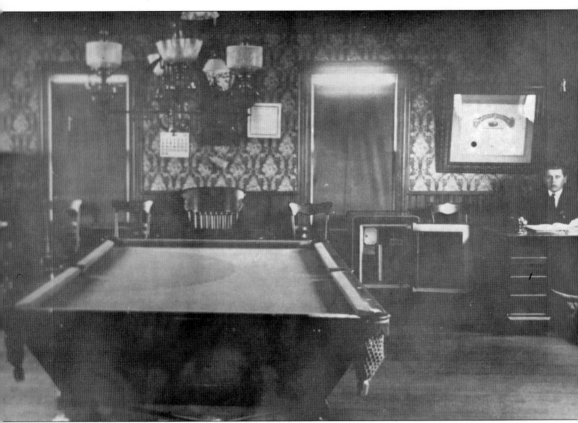

The second floor club room of the Pine Bush Hook and Ladder Company is shown here as it appeared in 1913. Seated at the desk is Clyde E. Morris, secretary of the company. The windows in this photograph face Center Street. A recent renovation of this room showed a well-worn floor around where the pool table once stood. (Courtesy of Pine Bush Hook and Ladder Company.)

This *c.* 1910 photograph shows one of the charter members of the Pine Bush Hook and Ladder Company, Clyde W. Morris. He served as president, secretary, and trustee of the fire company during its formative years. (Courtesy of the Pine Bush Hook and Ladder Company.)

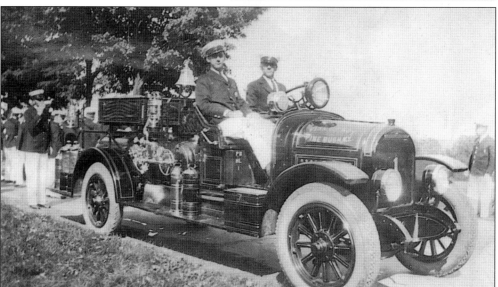

This *c.* 1935 photograph shows the 1925 Brockway Torpedo fitted with a LaFrance chemical engine that is still owned by the Pine Bush Hook and Ladder Company. Retired from active service, it is used for display and parades. Its cost in 1925 was $3,800. (Courtesy of Pine Bush Hook and Ladder Company.)

"The Whole Town's Talking"

HOME TALENT PLAY

Under Auspices

Pine Bush Hook & Ladder Co.

Friday, April 15th, 1932

AT 8:30 P. M. K. of P. HALL

General Admission - - 35 cents

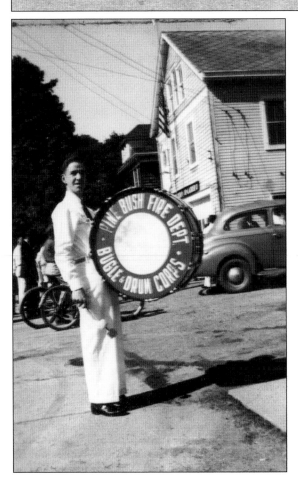

The Pine Bush Hook and Ladder Company has held many fund-raisers over the years, including pancake breakfasts, dinners, and dances. This ticket is from a 1932 play that took place in the Knights of Pythias Lodge next to the firehouse. (Courtesy of Fritz Meier.)

The Pine Bush Fire Department Bugle and Drum Corps was established in 1946. Charles Youngs holds a bass drum in front of the firehouse in this 1947 photograph. John Hogencamp from Walden was the director. James Wallace Westerfield Sr. and Hanford Youngs helped organize the band. The band was active until 1953. (Courtesy of Eric Palazolo.)

From left to right are Frederick Crist, Ruth Crist, and Patrick Kelly posing for this 1947 photograph. Frederick was a bugle player and Ruth was a majorette in the Pine Bush Fire Department Bugle and Drum Corps. These white uniforms were the first uniforms worn by the band. (Courtesy of Arthur and Kevin Kelly.)

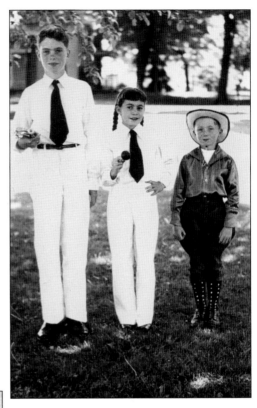

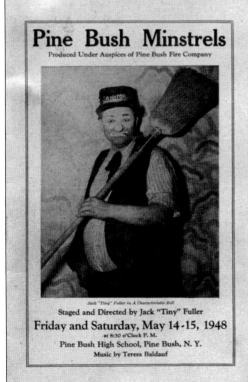

This 1948 minstrel show was produced by the Pine Bush Fire Department to raise funds for the bugle and drum corps to buy new uniforms. The fire department held many minstrel shows over the years, and they were always well attended. (Courtesy of Pine Bush Hook and Ladder Company.)

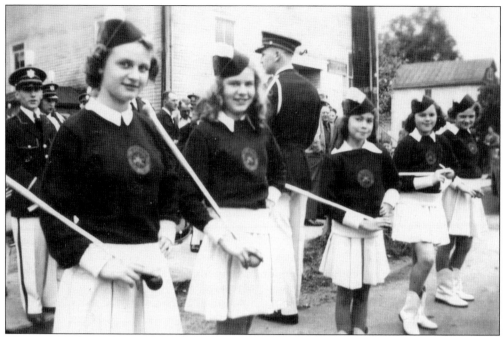

The Pine Bush Fire Department Bugle and Drum Corps majorettes are seen with their new uniforms for the 1948 Decoration (Memorial) Day parade in Pine Bush. From left to right they are Renee Bettinger, Marjorie Comfort, Ruth Crist, Judy Temple, and Joann Bettinger. George Low is the drum major in the middle. (Courtesy of Douglas Rockwell Sr.)

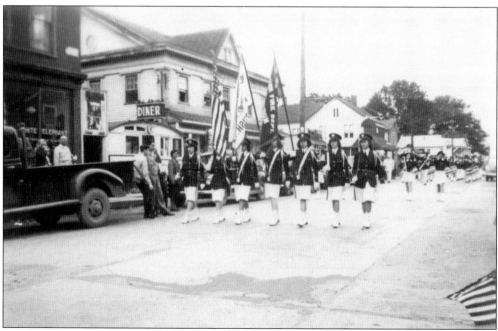

Main Street in Pine Bush is the backdrop for the 1948 Memorial Day parade. Burton's Diner and the building owned by Henry Pennissi are next to the band. The Bank of New York now occupies the place where these two buildings stood. (Courtesy of Douglas Rockwell.)

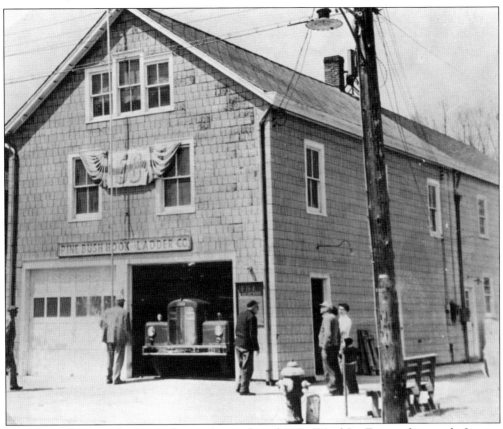

This 1957 photograph shows the newly purchased 1957 Ward La France fire truck. Its size prompted removal of the single garage doors in favor of a double garage door. The back part of the firehouse was added in 1948 to make a hall and a basement kitchen. (Courtesy of Pine Bush Fire Department.)

The members of the Pine Bush Hook and Ladder Company received new uniforms in April 1959. Several members are seen here with the uniform salesman. (Courtesy of Pine Bush Fire Department.)

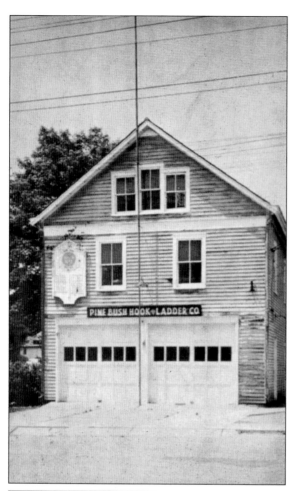

The Pine Bush Hook and Ladder Company provided a home for the Boy Scouts of America Troop 37 for many years. The firehouse hall in the back of the building was used by many other organizations over the years. It was sold to the Veterans of Foreign Wars (VFW) in 1968 and again in 2005. It is now the home of Pine Bush Physical Therapy. (Courtesy of Fritz Meier.)

The second Pine Bush firehouse was located on the corner of Center and Depot Streets. This firehouse was built in the 1960s. The Pine Bush Volunteer Ambulance Corps now occupies the building seen in this photograph. With the need for a substation, Station No. 2 firehouse was built in Thompson Ridge on land donated by Jack and Myrtle Thorn. (Courtesy of Pine Bush Hook and Ladder Company.)

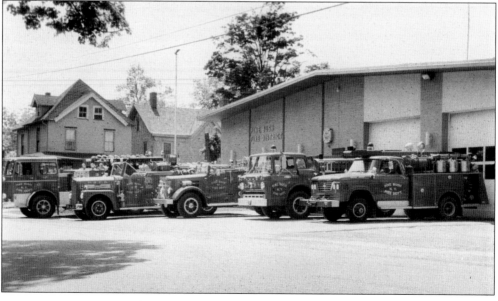

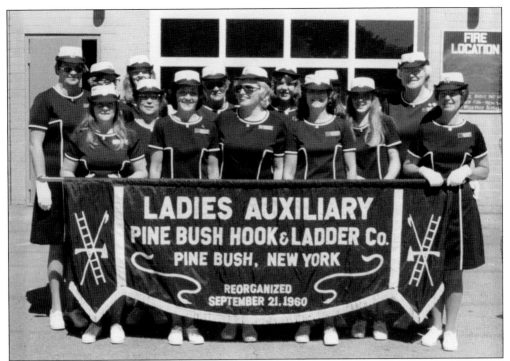

The ladies auxiliary of the Pine Bush Hook and Ladder Company was established in 1960. (Courtesy of Pine Bush Hook and Ladder Company.)

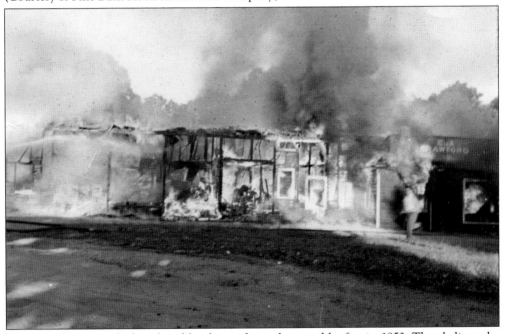

The E. and A. Crawford coal and lumberyard was destroyed by fire in 1953. They believe the fire was started by some neighborhood boys playing with matches. The intense heat melted the siding on the front of the firehouse across the street. The building was rebuilt and is now Lloyd'z Motor Workz motorcycle shop. (Courtesy of Fritz Meier.)

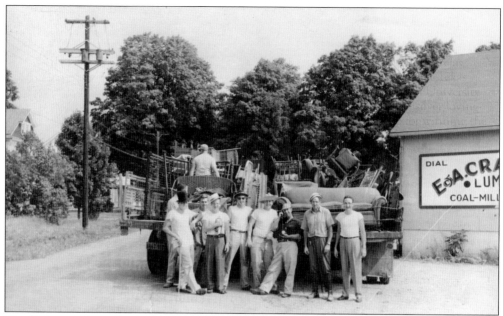

The Delaware River flood of 1955 left residents of Port Jervis with water-damaged homes. The Pine Bush Fire Department took two trucks of furniture and supplies to help victims of the flood. Pictured are, from left to right, William Neusinger, William Drexel, Richard Smith, Edward "Red" Gillespie, Charles Doyle, Robert Moorehead, Roland "Bucky" DuBois, Crawford Gillespie, and Richard Bonny. (Courtesy of Pine Bush Hook and Ladder Company.)

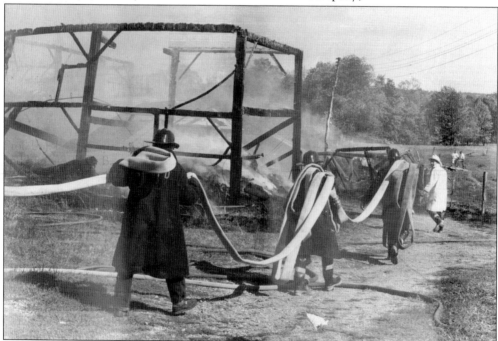

The Parr family lost its barn in this October 1963 fire. Richard Smith leads several members of the Pine Bush Hook and Ladder Company after the fire. The Parr farm was located on Hill Avenue. (Courtesy of Pine Bush Hook and Ladder Company.)

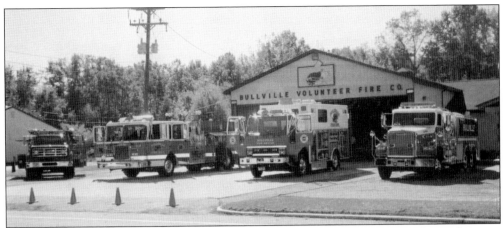

The Bullville Volunteer Fire Department was formed in 1974 and serves the fire district between Pine Bush, Circleville, Bloomingburg, and Montgomery. The Bullville Fire Department also has an active ladies auxiliary. (Courtesy of Donna Gady.)

Prior to having a police department, the town of Crawford relied on part-time constables. The first constables appointed during the formation of the town in 1823 were John C. Nicholson and Lewis Scott. Angelo Marco (center) was a constable in the late 1950s and is seen here with Teamsters Union president James "Jimmy" Hoffa (right) in this 1975 photograph. (Courtesy of the Marco family.)

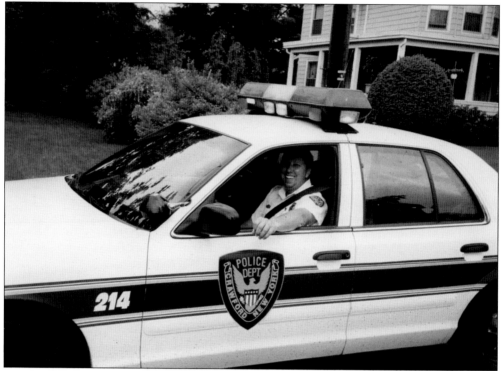

The Town of Crawford Police Department was formed in 1971. Police chief Daniel P. McCann, pictured here in this 2001 photograph, started with the department in 1976 as a part-time officer. In 1977, he became the police chief of seven part-time officers. Thirty-two years later, Chief McCann directs a police department of 13 full-time and 17 part-time employees. (Courtesy of Sgt. Eric Meier.)

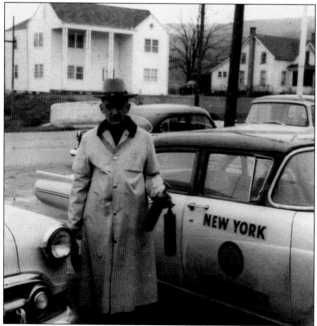

New York State trooper John "Frank" Huntoon patrolled the town of Crawford from 1957 through 1965. Huntoon owned the Old Homestead Hotel and Bar in Bullville until it was destroyed by fire in 1961. Frank and his wife, Rose Pondi Huntoon, built an ice cream stand where the hotel and bar stood. (Courtesy of John Huntoon.)

Seven

SCHOOLS

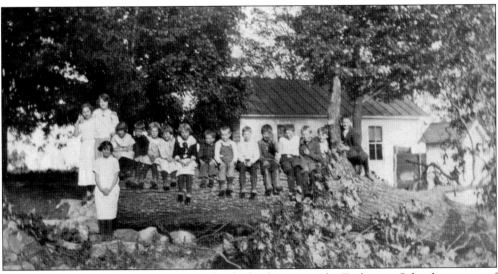

The town of Crawford District No. 1 school, also known as the Dickerson School, was one of the 10 schoolhouses in town. This 1925 photograph shows the schoolchildren in front of the schoolhouse. The school was located at the intersection of Orange County Road 17 and Hill Avenue, across the street from Dickerson's Mill. The building is now a private residence. (Courtesy of Helen Anderson Richardson.)

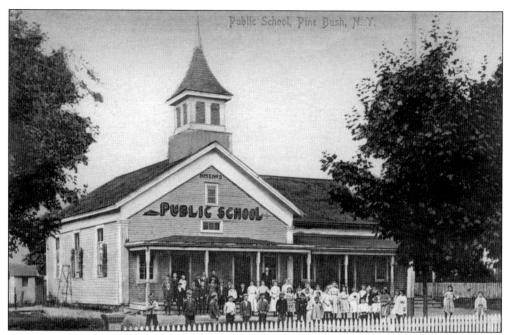

The town of Crawford District No. 3 school was located behind what is now the Crispell Middle School in Pine Bush. In the early part of the 20th century, some schoolboys allegedly "borrowed" a buggy from the blacksmith's shop and placed it on the peak of the school. It reportedly took several men to remove it in the morning. (Courtesy of the Pine Bush Area Library.)

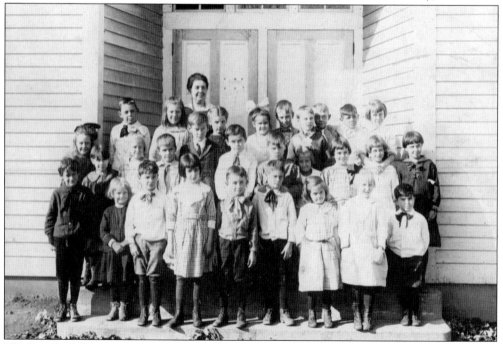

The Pine Bush District No. 3 school was located behind what is now the Crispell Middle School. This 1921 photograph shows the second grade class. The new Pine Bush School was built in 1925. (Courtesy of Helen Anderson Richardson.)

The town of Crawford District No. 4 school is shown here as it looked in the early 1900s. The steeple was removed, and this is now a private home. It is located on Collabar Road, just over the bridge of the Dwaarkill. (Courtesy of Elsie Rumpf Johnson.)

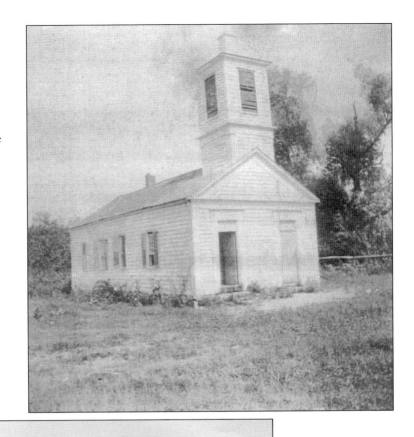

TEACHER'S CONTRACT

SUBD. 10, SECTION 47, TITLE 7, CONSOLIDATED SCHOOL LAW

I _Wm B. Falconer_ of _Walden_ county of _Orange_ a duly qualified teacher, hereby contract with the board of trustees of District No. _4_ town of _Cranford_ county of _Orange_ to teach the public school of said district for the term of _36_ consecutive weeks, commencing _Sept 4th 1900_ at a weekly compensation of _10_ dollars and —— cents payable at the end of each thirty days during the term of such employment.

And the board of trustees of said district hereby contract to employ said teacher for said period at the said rate of compensation, payable at the times herein stated.

Said board of trustees reserve the right to provide for a vacation or vacations of not more than ____ weeks in the aggregate, during said term.

Dated _Sept 4th_ 19_00_

Wm B. Falconer
Teacher

J. H. Clark
Trustees

This contract shall be executed in duplicate and one copy thereof given to the teacher and one retained by the board.

This teacher's contract was taken from the records and attendance book of the town of Crawford District No. 4 school in Searsville. The teacher, William B. Falconer, was paid $10 per week for the 36-week school year in 1900–1901. It is signed by trustee Joseph H. Clark. (Courtesy of Elsie Rumpf Johnson.)

107

This *c.* 1900 photograph shows the town of Crawford District No. 5 school located on Orange County Road 17. The Hopewell Presbyterian Church is in the distant left, and the Shawangunk Mountains can be seen the distance. Absent are the current houses and trees along the road. (Courtesy of Elsie Rumpf Johnson.)

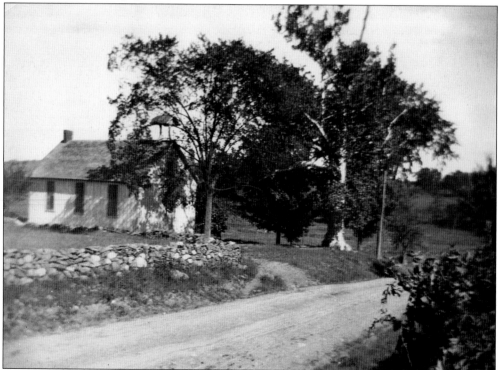

The town of Crawford District No. 5 school is seen in this *c.* 1900 photograph. The school was struck by lightning and destroyed by fire in 1937. The property was sold, and a new school was built one-half mile down Orange County Road 17. (Courtesy of Elsie Rumpf Johnson.)

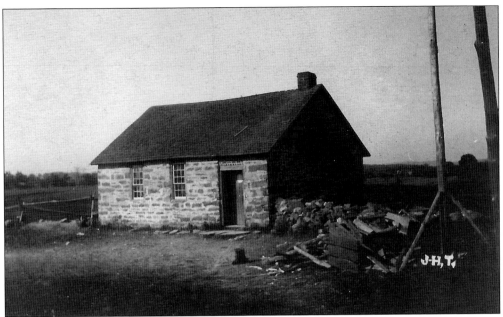

The town of Crawford District No. 8 school in Bullville was also known as the Bullville Academy. This turn-of-the-20th-century photograph shows the schoolhouse, which was located on New York State Route 302 near the intersection of Burlingham Road. (Courtesy of Louis Roberson.)

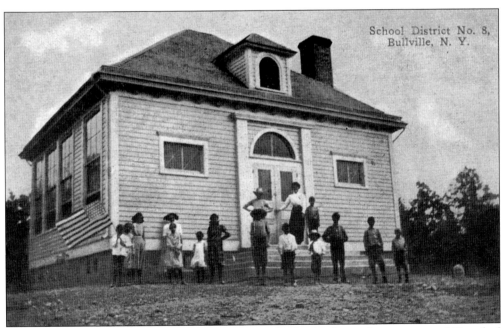

When Bullville's school population outgrew the Bullville Academy, the new town of Crawford District No. 8 schoolhouse was built on New York State Route 302 just past the intersection of New York State Route 17K toward Middletown. (Courtesy of Louis Roberson.)

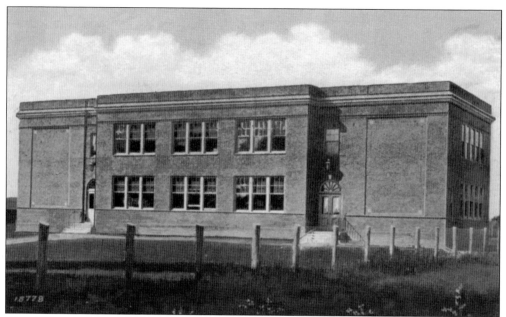

The old District No. 3 school in Pine Bush was demolished to make room for the new District No. 3 school around 1925. This building housed the youngest children on the first floor and the older children on the second floor. This building is now the back section of Crispell Middle School, where the cafeteria is currently located. (Courtesy of Fritz G. Meier.)

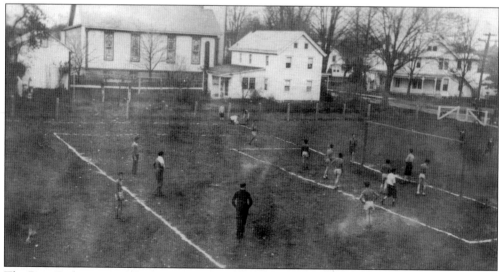

The Pine Bush soccer team played on this field in front of the school. New York State Route 302 is in the background. The Pine Bush Methodist Church is seen to the left. In 1941, the field was used to build an addition to provide more classrooms for the newly centralized Pine Bush Central School District. (Courtesy of Dorothy Goldsmith Boniface.)

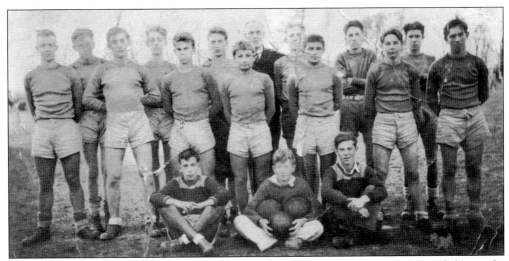

The Pine Bush High School soccer team from 1938 is shown here. Pictured from left to right are (first row) Ernest Gnehm, Joseph Green, and Alfred Gettler; (second row) Harry Stratton, William Stien, Kenneth Goldsmith, Stephen Zaverskey, Nicholas Zaverskey, Charles Ferris, and William Lockwood; (third row) Phillip Edmunds, Morse Platt, Emil Halm, coach Perrine, Leon Phillips, Raymond Kain, and Adrian McKaig. The team record was five wins, two losses, and four tied games. (Courtesy of Dorothy Goldsmith Boniface.)

In 1941, a vote was held to create the Pine Bush Central School District. Town of Crawford District No. 5 school board clerk Everett Aumick takes notes by the light of a lantern during the meeting, which eventually closed the school located on Orange County Road 17 in Thompson Ridge. (Courtesy of Jane Aumick.)

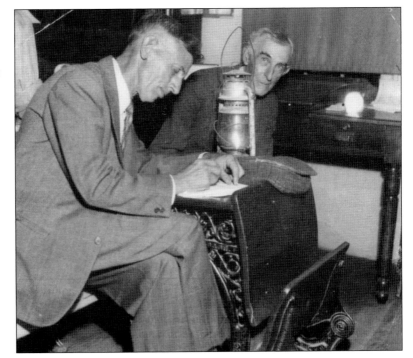

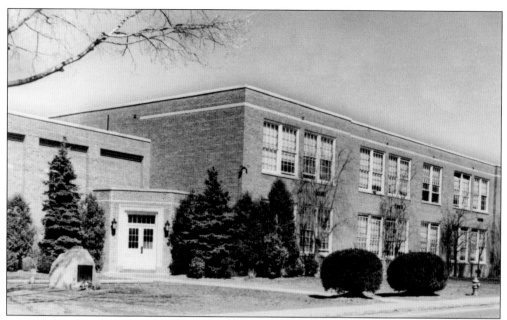

The Pine Bush Central School District needed more room so a large addition was added to the District No. 3 school in 1941. This *c.* 1955 photograph shows the front of the school now known as Crispell Middle School. Grades kindergarten through 12th grade went to this school. (Courtesy of Dorothy Goldsmith Boniface.)

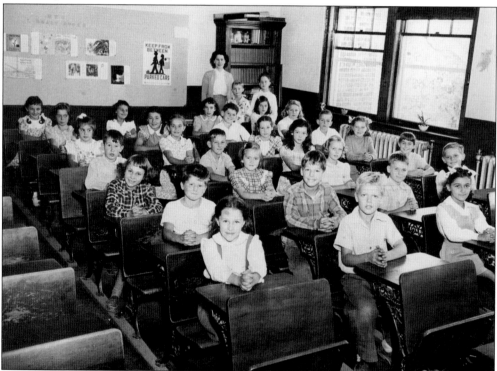

Isabelle Ross's 1947 fourth grade class of Pine Bush Central School is shown here. (Courtesy of Arthur and Kevin Kelly.)

Eight

THE RAILROAD

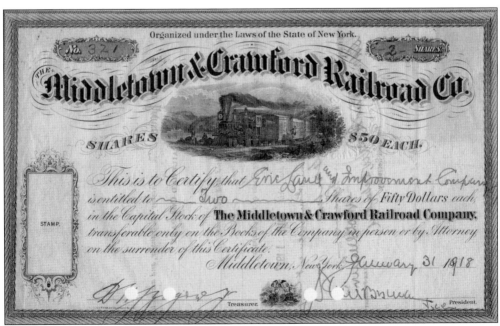

The Middletown and Crawford Railroad was built in 1871 from Middletown, near Crawford Junction, to Pine Bush. It made stops in Circleville, Bullville, Thompson Ridge, VanKeuren Road, and Pine Bush. This 1918 stock certificate was for two shares valued at $50 each and was owned by the Erie Land and Improvement Company. (Courtesy of Fritz Meier.)

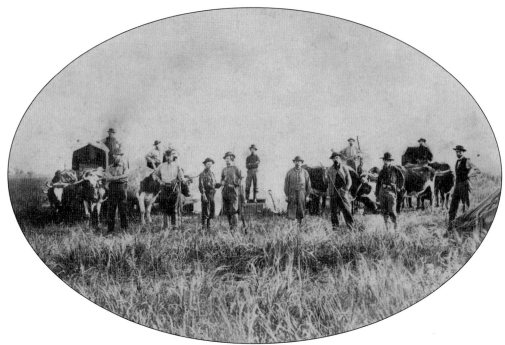

This 1871 photograph shows the crew of Messrs. D. C. Jackson and Company constructing the Middletown and Crawford Railroad. Construction of the 10 miles of track started in April 1871, and it was completed at its terminus in Pine Bush on August 21, 1871. (Courtesy of the Town of Crawford Historical Society.)

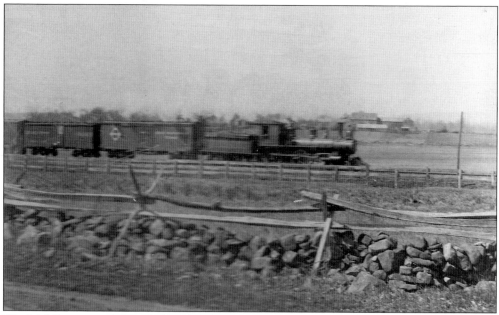

The Middletown and Crawford Railroad was organized on May 27, 1868, and incorporated on August 3, 1868. The rail line leased its track to the New York and Oswego Midland Railroad. This 1898 photograph shows the train heading west back to Middletown near Roberson Avenue. (Courtesy of Louis Roberson.)

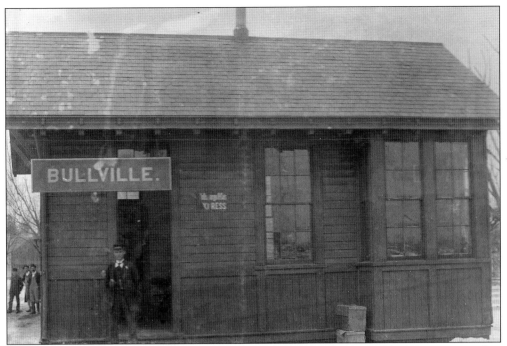

The New York and Oswego Midland Railroad had financial difficulty and had its assets seized in 1875. President of the Middletown and Crawford Railroad, Daniel Thompson, bought a locomotive and tender, a coach, and a boxcar for $5,450 at an auction. This photograph shows the railroad station in Bullville. (Courtesy of Louis Roberson.)

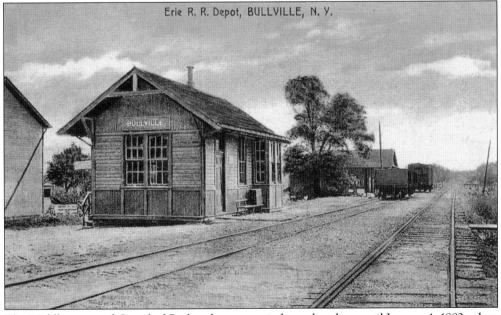

The Middletown and Crawford Railroad ran as an independent line until January 1, 1882, when the track was leased by the Erie Railroad. When rail service stopped in 1978, the Bullville Station was moved to Circleville by Al Schubert for use on his property on Goshen Turnpike. (Courtesy of Louis Roberson.)

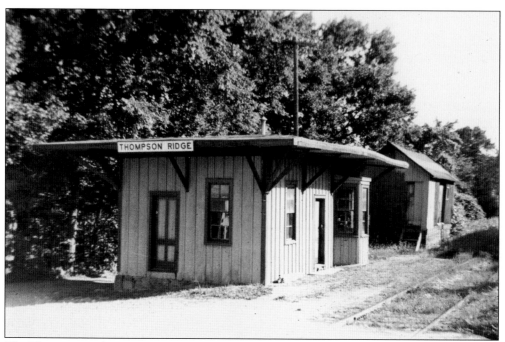

The Thompson Ridge Railroad Station is captured in this photograph from the 1950s. Creameries were located in Circleville, Bullville, Thompson Ridge, and Pine Bush. Local farmers relied on these rails to bring their products to market. This station was located on the left side of Orange County Route 17 going toward Searsville. (Courtesy of Fritz Meier.)

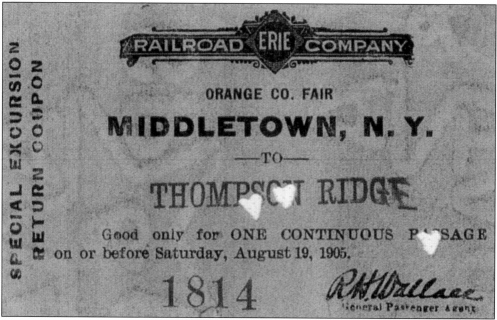

The Erie Railroad leased the Middletown and Crawford Railroad from 1882 until 1929 when it became the owner of all capital stocks of the Middletown and Crawford Railroad. This 1905 train ticket was for passage from Thompson Ridge to the Orange County Fair in Middletown. (Courtesy of Elsie Rumpf Johnson.)

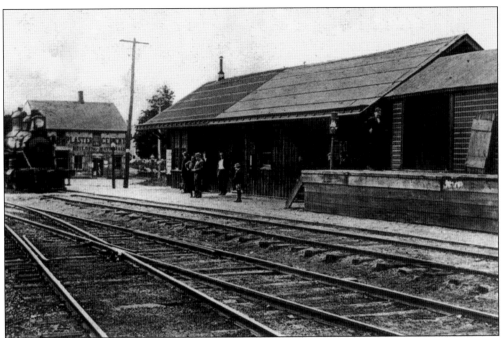

This turn-of-the-20th-century postcard shows the platform of the Pine Bush railroad station. VanKeuren's Lumber and Feed can be seen in the background. The turntable just past this station was used to turn the train around for its trip back to Middletown. The turntable was located where the Agway parking lot is today. (Courtesy of Fritz Meier.)

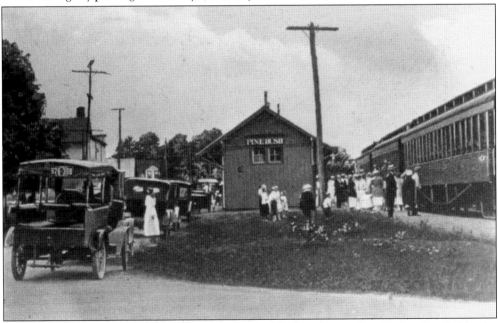

Passenger service on the Middletown and Crawford Railroad started in 1871 and ended in the 1950s. Local hotels and inns would send vehicles to the station to pick up guests. The station was located on Railroad Avenue where Joe's Small Engine Repair is located today. (Courtesy of Fritz Meier.)

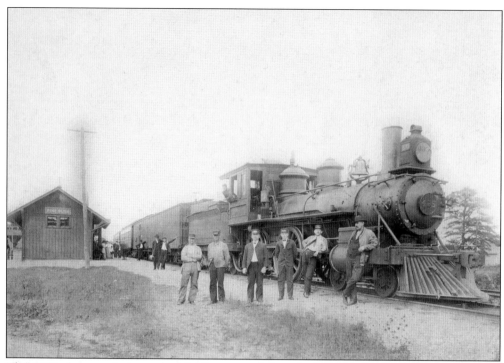

This 1907 photograph shows the Middletown and Crawford Railroad station in Pine Bush with the No. 435 4-4-0 train. Pictured are (order unknown) conductor H. A. Hopper, baggage handler Charles Terwilliger, trainman F. C. Martin, milk handler Frank Decker, engineer James Doe, fireman Robert Decker, and stationmaster Edgar Armstrong. (Courtesy of Louis Roberson.)

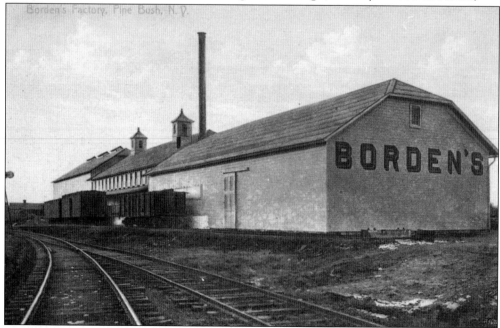

The Borden's Creamery was located along the tracks of the Middletown and Crawford Railroad in Pine Bush. Borden's was one of the biggest employers in the town. (Courtesy of Fritz Meier.)

Nine

THE PEOPLE OF CRAWFORD

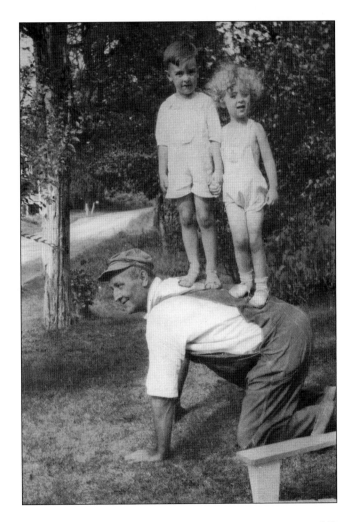

William Bruyn supports Raymond and Elsie Rumpf in this 1938 photograph taken near Searsville. (Courtesy of Elsie Rumpf Johnson.)

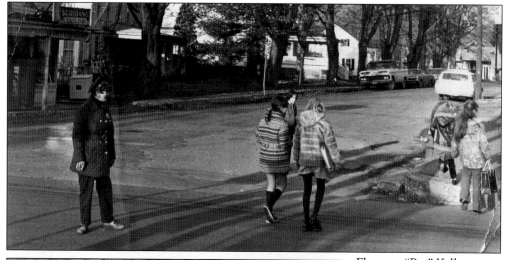

Florence "Peg" Kelly is the school crossing guard in this early 1970s photograph. It was taken at the intersection of Main Street and Maple Avenue. The old Just-a-Mere Shop is in the background on the left. The building was razed not long after this photograph was taken. (Courtesy of Kevin and Art Kelly.)

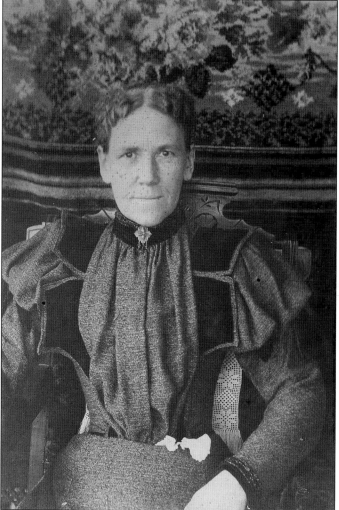

Capt. Theodore Roberson married Josephine Bull, the woman in this 1898 photograph. Their son Clarence D. Roberson took all the photographs in 1898 from Bullville in this publication. Josephine is a decedent of Thomas Bull, for whom Bullville is named. Thomas's son Daniel built the family house on Roberson Avenue. (Courtesy of Louis Roberson.)

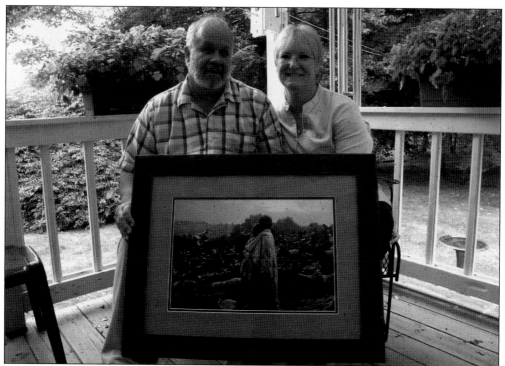

Barbara Kelly Ercoline and Nicholas Ercoline of Searsville, known locally as "Bobbi and Nick," were recently in the world spotlight. Bobbi and Nick are the couple huddled under a blanket immortalized by photographer Burk Uzzle at the original Woodstock Festival in 1969. Bobbi and Nick have been married since August 1971; they have two children, Matthew and Luke. (Photograph by Fritz Meier, with permission of Burk Uzzle.)

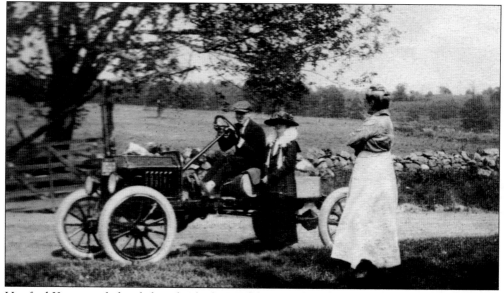

Hanford Youngs is behind the wheel of a Model T speedster in this 1919 photograph. Youngs went on to open Youngs Service Station in Pine Bush. He also served in the Pine Bush Hook and Ladder Company as chief. (Courtesy of Eric Palazolo.)

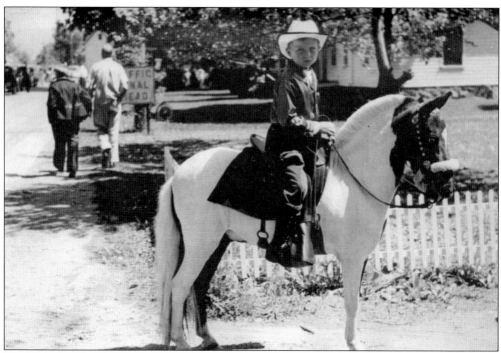

Patrick Kelly was always seen around Pine Bush dressed as a cowboy on his trusty steed, "Tony the Pony." (Courtesy of Arthur and Kevin Kelly.)

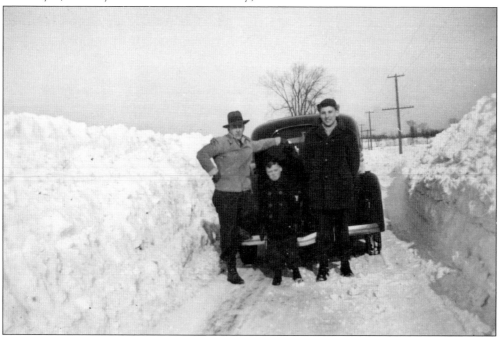

The January 1945 snowstorm dumped just 14 inches of snow, but heavy winds made the snow drift, causing many roads to shut down. Douglas Rockwell, his son Douglas, and Reuben Gillespie are standing behind a 1936 Ford Coupe on New York State Route 302, near the Hopewell Farm. (Courtesy of Douglas Rockwell Sr.)

Jack and Shirley Stein owned the Grand Union Store and the United Cigar Store on Main Street in Pine Bush. Shirley is seen with Douglas Rockwell in front of the store in this 1940 photograph. William Ribbecke was a butcher and is leaning on his shovel in the center. Emma's Variety Store was in between. The Steins' nephew Seymor Cohen would later build his store, Seymor's, on this very spot. (Courtesy of Douglas Rockwell Sr.)

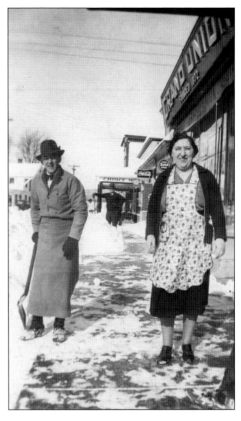

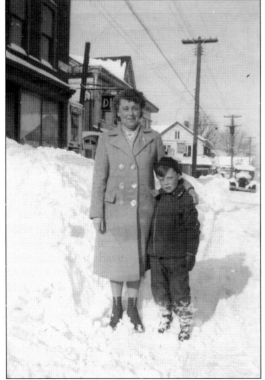

The snowstorm of 1945 paralyzed the town of Crawford. Marjorie Rockwell and her son Douglas are standing on Main Street in Pine Bush near its intersection with New Street in this photograph. (Courtesy of Douglas Rockwell Sr.)

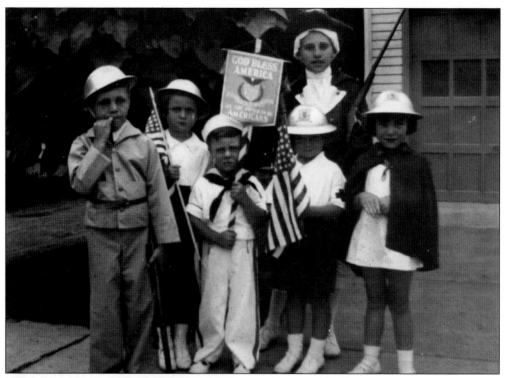

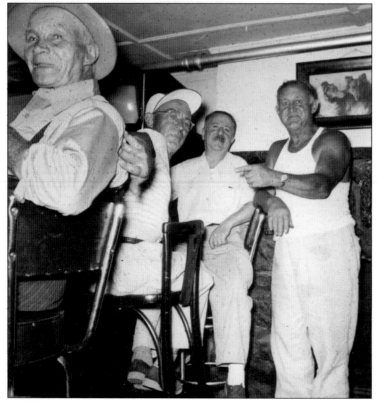

This group of children is getting ready to march in the 1948 Memorial Day Parade. From left to right are Benjamin Gillespie, unidentified, Douglas Rockwell Sr., Reuben Gillespie (back), unidentified, and Elva Costello. (Courtesy of Doug Rockwell Sr.)

Many local residents enjoyed their favorite beverages at Phoebe's Old Homestead Hotel and Bar in Bullville. This 1950s photograph was taken in the basement bar. (Courtesy of John Huntoon.)

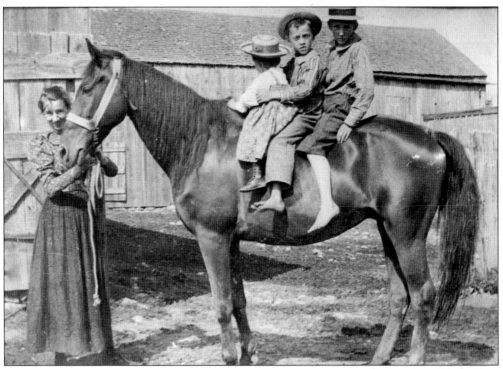

Sara Clark is holding the horse in the c. 1896 photograph. From left to right, Arthur, Henry, and Raymond Rumpf are sitting on the back of the horse on the family farm in Searsville. (Courtesy of Elsie Rumpf Johnson.)

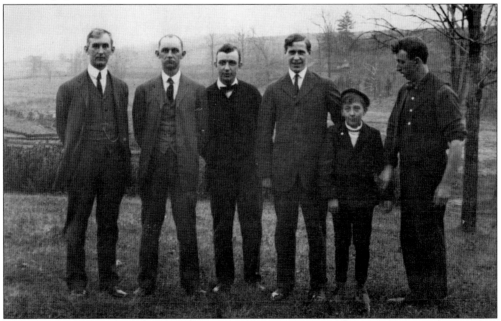

This 1904 photograph shows, from left to right, Theodore and George Clark (owners of Clark Brothers Store in Thompson Ridge), Benjamin Shafer, unidentified, Arthur Rumpf, and Richard Shafer. (Courtesy of Elsie Rumpf Johnson.)

In 1929, the Friends of Pine Bush were the charter organization for the Boy Scouts of America Troop 37 in Pine Bush. Charles Youngs (right) is pictured with a fellow scout in front of the water tower near the Marietta Silk Mill on Center Street near Kelly Avenue. Troop 37 has remained active since 1929. (Courtesy of Eric Palazola.)

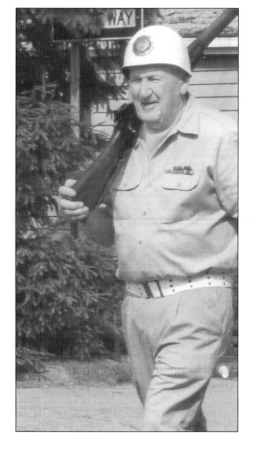

Pine Bush native and current resident George Low proudly served his country in Europe during World War II. Low is seen marching in his 60th Memorial Day parade in Pine Bush. The road leading into the Tess Chessari Memorial Town Park is named in his honor for his community service and volunteerism over many years. (Courtesy of Erika Scheuermann.)

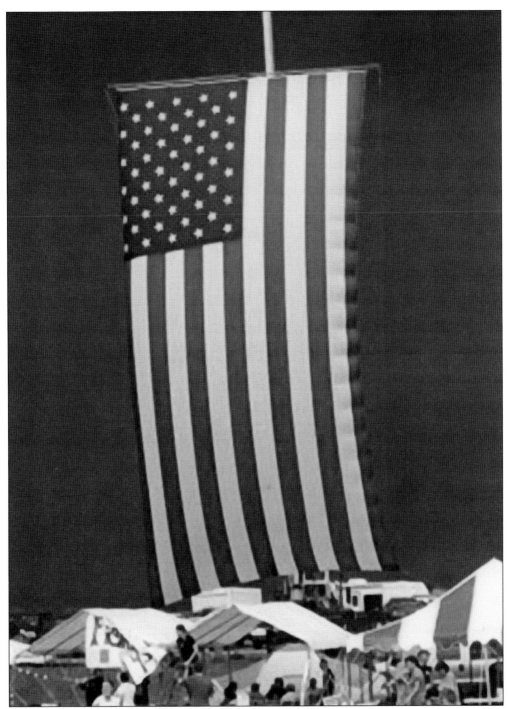

Patriotism, volunteerism, charity, hard work, and dedication are attributes that define the town of Crawford and its people. This 2008 photograph was chosen to end this book because it demonstrates all of the above attributes. Local residents have raised more than $735,000 over the last five years for the American Cancer Society during the annual Pine Bush Relay for Life Cancer Walk. (Courtesy of Fritz Meier.)

www.arcadiapublishing.com

Discover books about the town where you grew up, the cities where your friends and families live, the town where your parents met, or even that retirement spot you've been dreaming about. Our Web site provides history lovers with exclusive deals, advanced notification about new titles, e-mail alerts of author events, and much more.

MADE IN THE USA

Arcadia Publishing, the leading local history publisher in the United States, is committed to making history accessible and meaningful through publishing books that celebrate and preserve the heritage of America's people and places. Consistent with our mission to preserve history on a local level, this book was printed in South Carolina on American-made paper and manufactured entirely in the United States.

This book carries the accredited Forest Stewardship Council (FSC) label and is printed on 100 percent FSC-certified paper. Products carrying the FSC label are independently certified to assure consumers that they come from forests that are managed to meet the social, economic, and ecological needs of present and future generations.

FSC
Mixed Sources
Product group from well-managed
forests and other controlled sources

Cert no. SW-COC-001530
www.fsc.org
© 1996 Forest Stewardship Council

Find Your Place in History.